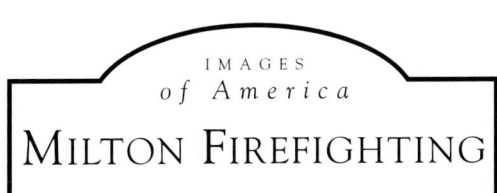

This image of Milton Village was painted by Stephen Badlam, the clerk of the Fireward Society of Dorchester and Milton. The painting shows Milton Village as it appeared before 1800. The small shed building in the foreground is the first fire engine house where fountain engine No. 1 was kept and maintained. It was located on the Dorchester side of the Neponset River, just below the bridge leading to Milton. On the Milton side of the bridge to the right is John Lillie's home and shop. Early American firehouses were often nothing more than a small shed just large enough to store the engine and other firefighting equipment.

*On the cover:* Milton firefighters battled a blaze that broke out at Samuel Gannett's Grain, Flour, Hay, and Straw facility on Adams Street in Milton Village on October 15, 1906. Gannett's was an economic asset to the town and employed many local people. Fortunately the fire was stopped before any serious structural damage was done, and the facility reopened some time later and continued to operate in Milton for many years. (Courtesy of the Milton Firefighters Memorial Archives.)

IMAGES
of America

# MILTON FIREFIGHTING

Brian A. Doherty

ARCADIA
PUBLISHING

Copyright © 2007 by Brian A. Doherty
ISBN 978-0-7385-4988-0

Published by Arcadia Publishing
Charleston SC, Chicago IL, Portsmouth NH, San Francisco CA

Printed in the United States of America

Library of Congress Catalog Card Number: 2006939085

For all general information contact Arcadia Publishing at:
Telephone 843-853-2070
Fax 843-853-0044
E-mail sales@arcadiapublishing.com
For customer service and orders:
Toll-Free 1-888-313-2665

Visit us on the Internet at www.arcadiapublishing.com

*This book is dedicated to the memory of all who ever served the Milton Fire Department.*

# CONTENTS

| | | |
|---|---|---|
| Acknowledgments | | 6 |
| Introduction | | 7 |
| 1. | The Development and Growth of the Milton Fire Department | 9 |
| 2. | The Firemen and Their Machines | 23 |
| 3. | The Chiefs of the Milton Fire Department | 43 |
| 4. | Life of a Milton Fireman | 51 |
| 5. | Milton Firefighting | 59 |
| 6. | The Milton Firefighter's Relief Association | 103 |
| 7. | In Memoriam | 111 |
| 8. | Milton Fire and Rescue | 119 |

# Acknowledgments

The Milton Historical Society has been dedicated to the preservation and documentation of Milton history since its founding in 1904. Numerous photographs from the society's collection have been used in this book. I wish to acknowledge all the members of the Milton Historical Society who are responsible for collecting and maintaining these priceless artifacts of Milton history. Edith Clifford, Anthony Sammarco, Nadine Leary, George and Anne Thompson, Jeanette Peverley, and Linda Pirie have been especially cooperative toward this effort. The staff of the Milton Public Library, which houses the archives of the society, including many of the photographs reprinted in this book, has been very helpful and supportive of this project, especially Dan Hacker and Shirley Pyne.

I wish to thank my editor at Arcadia Publishing, Erin Stone, for her guidance and assistance. Additionally, I wish to thank Teresa Sexton, Walter Fitzgerald, and Robert McGee for their enthusiastic support for this project and for their writing and editing contributions.

Milton firefighter James Quinn and retired firefighter Robert McGee have contributed numerous photographs from their collections for this project. Capt. Robert Tucker of the Dennis Fire Department submitted several excellent photographs from his private collection in memory of his father, Milton firefighter Robert Tucker Sr. For all these photographs I am most appreciative. I am also grateful to Glenn and Peggy Caterer of Photoquick of Quincy for their expertise and professionalism in the development and re-creation of many of the images in this book. Many of the photographs covering the period of 1974–1976 were donated to the Milton Firefighters Memorial Archives by Milton resident and photographer Donald Finn.

Capt. John Fleming of the Milton Auxiliary Fire Department has been very helpful in assisting me with the collection and preservation of many of the photographs and artifacts of the Milton Firefighters Memorial Archives. Many of these photographs are included in this work. All the members of the Milton Auxiliary Fire Department have been of invaluable assistance since the archive was established in 1993.

My fellow members of the Milton Firefighter's Relief Association have entrusted me as their secretary-clerk for more than 20 years. This position has made me more aware and appreciative of the history of the Milton Fire Department than I ever would have been. For their credence, I am very grateful. I appreciate the confidence and assistance provided over these years by association president Jeffrey Murphy, past president Joseph Garrity, and treasurer Kevin Mawn.

I am thankful to all the members of my family for their encouragement, and I codedicate this book to the memory of my father, Robert K. "Red" Doherty (Milton Fire Department, 1952–1982).

Finally, all author proceeds from the sale of this book are to be directed to the Milton Firefighters Relief Association. The association was founded in 1892 for the purpose of assisting Milton firefighters and their families in times of illness, injury, and/or death. Your consideration of our mission while purchasing this book is gratefully appreciated.

# Introduction

When studying the history of Milton, one soon becomes aware of the town's early association with the town of Dorchester. Formerly known as Unquity, Milton was a very small and mostly forested section of Dorchester when it was set off and granted township by the Massachusetts General Court in 1662.

After its establishment, Milton continued to share many social, economic, and religious ties with its neighbor. In many ways, Milton Village and Dorchester Village were one and the same community. It is not surprising, therefore, to learn that when the two communities sought to create an organization for the protection of their common interests from fire, it was a community effort. The creation of the Fireward Society of Dorchester and Milton in 1793 is an early example of mutual aid—two towns coming together in a common effort to confront the age-old problem of disastrous and destructive fire. They purchased an engine, which they named fountain No. 1, and created a voluntary force composed of an equal number of men from both communities. The engine was kept in a small shed and then in a larger firehouse located on the Dorchester side of the Neponset River, ready to respond when needed.

With the creation of the Granite Railway in East Milton in 1826, that section of town began to grow. Soon it was agreed to establish another fire protection organization there. The Danube engine No. 2 was purchased in 1827. In 1846, another engine, the hydrant, was purchased by the town and installed in an engine house on Squantum Street near Adams Street. This house was later moved to Granite Avenue, near Bassett Street. These hand engines were drawn by manpower, not horses, and were common throughout America in this period. About 1850, the Granite Hook and Ladder Company was formed in East Milton to provide ladder and rescue work for the town. These were the humble beginnings of what became known in the 19th century as the Milton Fire Department.

When the town of Dorchester was annexed by the City of Boston in 1870, all Dorchester fire companies including the Fountain Engine Company were added to the roster of the Boston Fire Department. After the great fire of 1872, that department was reorganized under a military-style command and the fountain was soon replaced by more up-to-date fire apparatus, which later became known as Boston engine No. 16, supplemented by Ladder Company No. 6. These fire companies continue to provide mutual aid fire protection in Milton Village to this day.

By 1880, the Town of Milton realized that its fire department had not kept up with the growing population of the town. To address the problem, a new firehouse was built in Milton Center behind the town hall, and a chemical engine was purchased and installed there in 1881. This engine was state-of-the-art for its time and was a sign of the serious attention town leaders were paying to the issue of fire protection. In 1887, a larger firehouse was built adjacent to the chemical engine house, and a steam fire engine was purchased and situated there. Soon a hose

wagon and a ladder truck were purchased for that larger firehouse. By 1893, a new firehouse was built in East Milton Square at Adams Street and Granite Avenue, and a new hose wagon was purchased and installed there.

As the population of Milton continued to grow and expand geographically, fire department leaders began proposing the establishment of another firehouse for the Brush Hill section of town. In 1896, a number of firefighting tools and other equipment were purchased and installed in a small shed on private property at the corner of Canton Avenue and Dollar Lane. A 40-foot fire alarm bell tower was erected nearby. Upon hearing an alarm of fire, off-duty and call firemen would respond to the location, bringing their equipment to the scene of the fire to meet up with the later arriving engines from the town center and East Milton. Following a tragic fire at a Brush Hill Road residence in February 1900, town leaders agreed to build and equip a new firehouse for the better protection of the citizens and their property in the western section of town. The Atherton Street fire station was completed in 1901, and a hose wagon, hose No. 4, was installed there.

Since 1900, the Milton Fire Department has witnessed many changes not unlike many other towns in the Greater Boston area. For example, the motorization of apparatus began in 1914 and was completed when the last horse was retired in 1919. Fire hydrants and fire alarms were laid out throughout the town as the population growth demanded. The first civil service exam for Milton firefighters was held in 1901, and mutual pacts were established between the Boston, Quincy, and other area fire departments.

Today the Milton Fire Department is fully professional and operates within a much busier and active suburban environment than its predecessors, the Fountain and Hydrant Engine Companies of the volunteer era. Milton firefighters and members of the Boston Fire Department continue to assist one another on fire calls in Milton Village, carrying on a tradition of community that began in 1793. That spirit of community continues to thrive in the Milton Fire Department to this day and is well documented in the following chapters of *Milton Firefighting*.

# One

# The Development and Growth of the Milton Fire Department

THIS entitles *John Lillie Esqr* to one Share or Hundredth Part of the Engine and Fund of the FIREWARD SOCIETY in *Dorchester* and *Milton*, and to be a Member of the said SOCIETY, according to their articles agreed upon for the relief of those who may be distressed with calamitous Fire.

Stephen Badlam
Enos Blake
} COMMITTEE.

BADLAM

This certificate of the Fireward Society of Dorchester and Milton is a facsimile of the one issued to John Lillie, Esq., in 1794. Lillie was a famed veteran of the Revolution, having been at the siege of Boston and served as aide-de-camp to Gen. Henry Knox in 1782. He was married to a daughter of local resident Daniel Vose. They made their home in Milton Village. The certificate declares Lillie's membership in the Fireward Society of Dorchester and Milton, which organized local residents and businessmen into a fire protection mutual aid society.

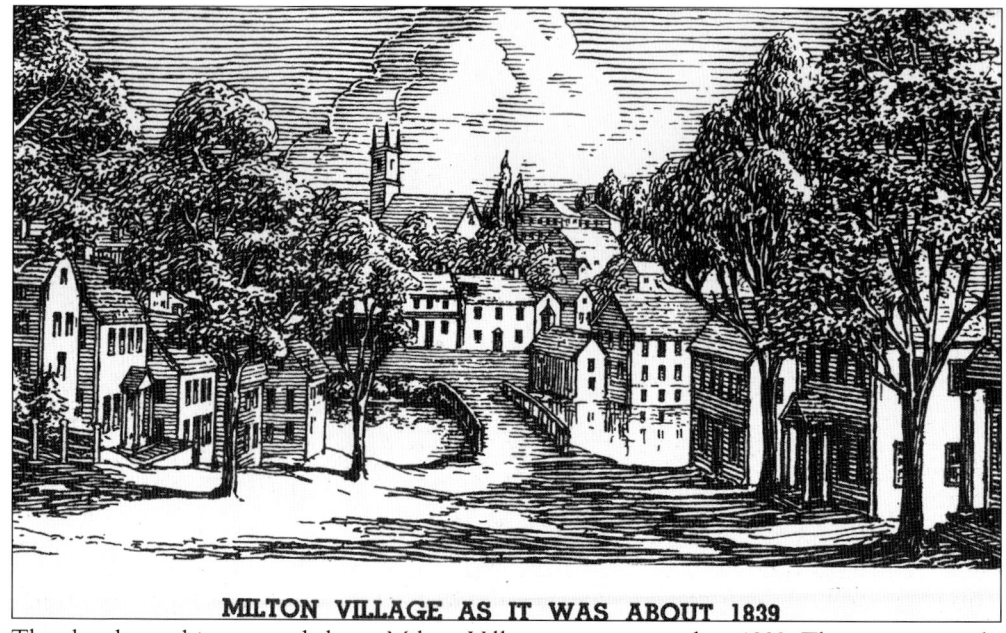

**MILTON VILLAGE AS IT WAS ABOUT 1839**

The sketch on this postcard shows Milton Village as it appeared in 1839. The view is north, looking across the bridge toward Dorchester where an improved firehouse appears with a bell tower on top (center and right at end of bridge). It reflects the rapid growth of the village since the Fireward Society was established in 1793.

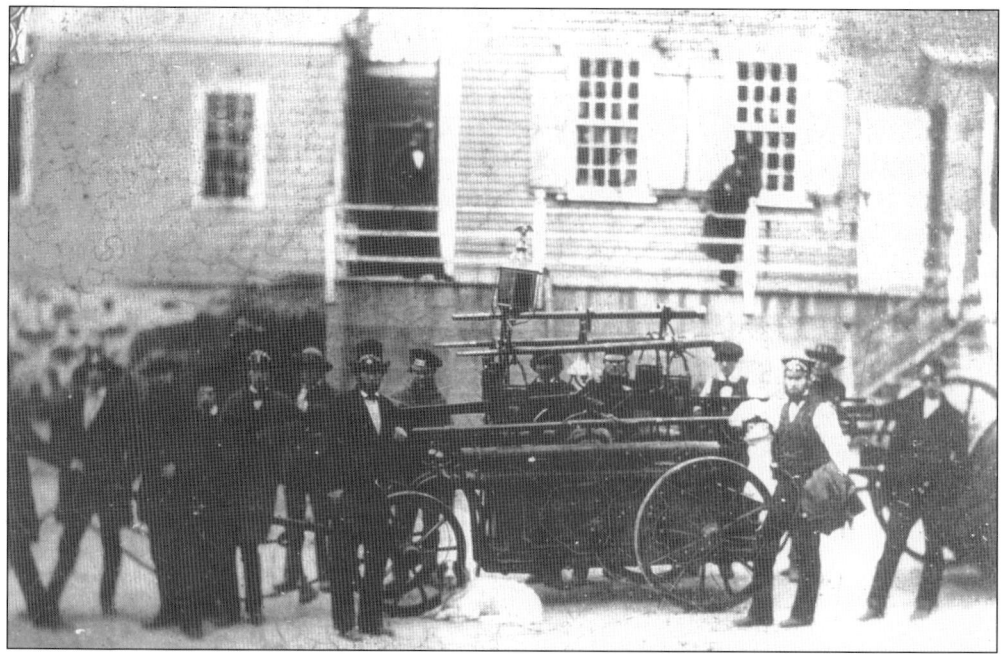

The Fountain Engine Company of Dorchester and Milton assembled in 1858 for this photograph taken in front of the Talbots store on Washington Street in Dorchester Village. The company was composed of an equal number of men from Dorchester and Milton. These men were exempt from military duty, relieved of their poll taxes, and paid an annual stipend of $5, and later $10, each.

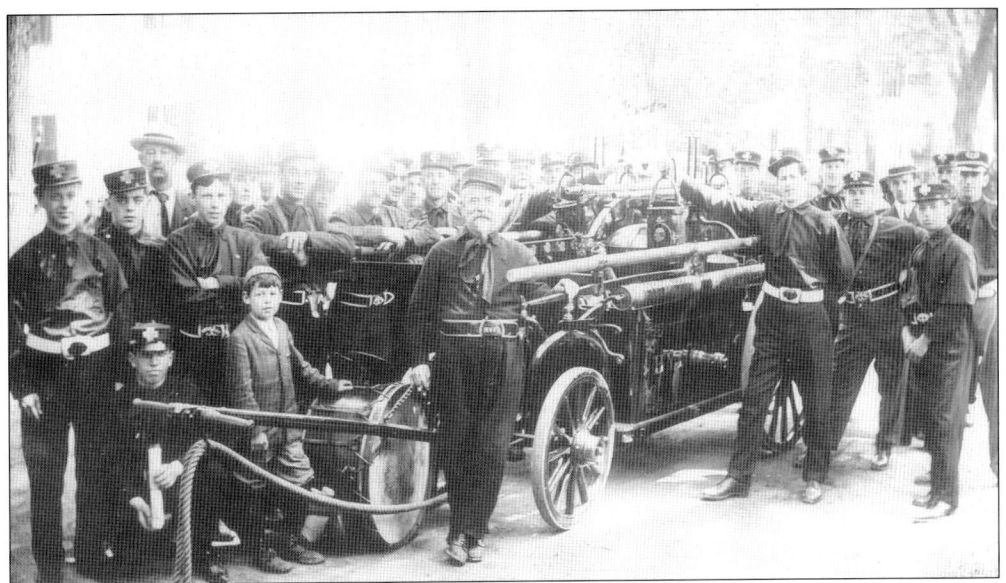

This photograph of the hydrant engine and Milton firemen was taken at a fire muster held in Salem in 1909. The firemen are wearing their parade dress clothing complete with belts and ties. Firemen's musters and parades were popular community events in the 19th and early-20th centuries.

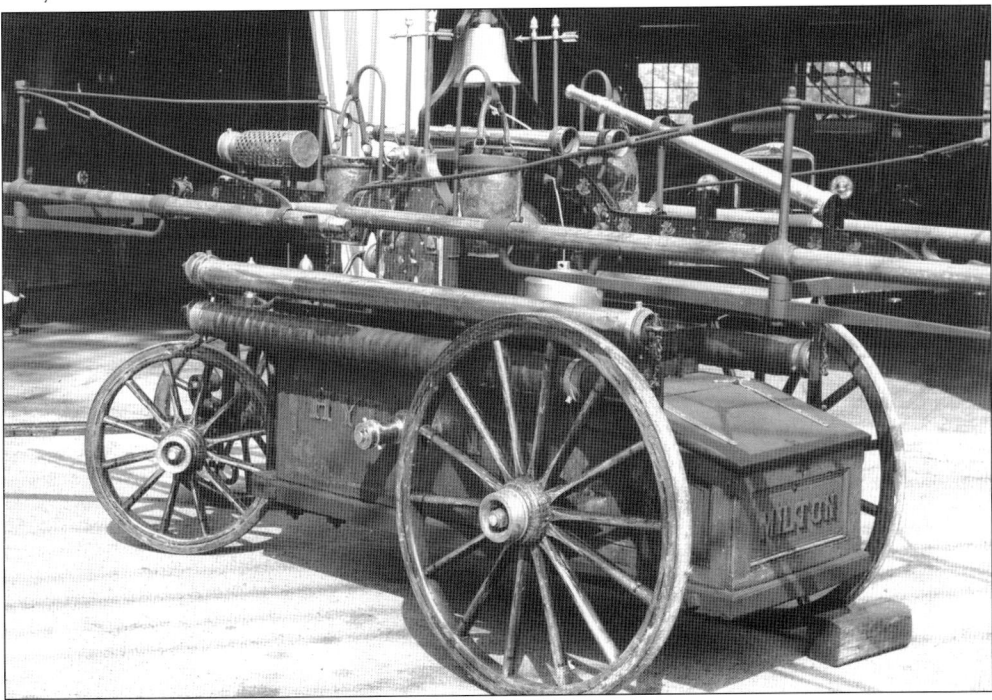

The hydrant engine was built for the Town of Milton by the Hunneman Company of Boston in 1846. William C. Hunneman, who had been an apprentice of Paul Revere, established one of the first companies to manufacture fire engines in America in 1792. The company was the most prolific builder of these machines in the Northeast during much of the 19th century. This engine was purchased by the Town of Milton in 1846 for $1,200.

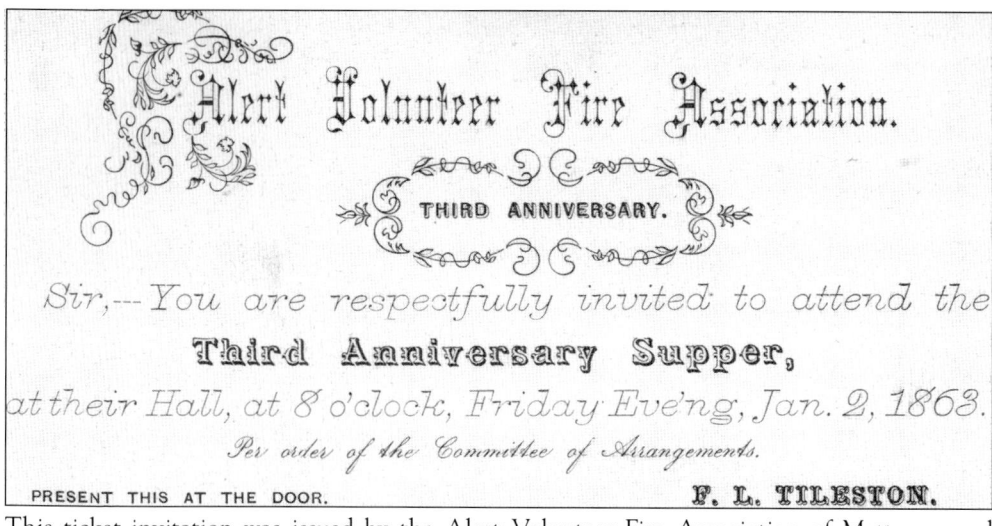

This ticket invitation was issued by the Alert Volunteer Fire Association of Mattapan and Milton. Its firehouse was located on the Milton side of the Neponset River along what today is called Blue Hills Parkway. The third anniversary supper was held in its fire hall, which replaced an earlier building that accidentally burned down in 1858. F. L. Tileston was a prominent resident and co-owner of the Tileston and Hollingsworth Paper Mill, also located on the Milton side of the Neponset River. Like the Fountain Engine Company, the Alert Engine Company was made up of men from Mattapan with an equal number from Milton. (Courtesy of the Milton Historical Society.)

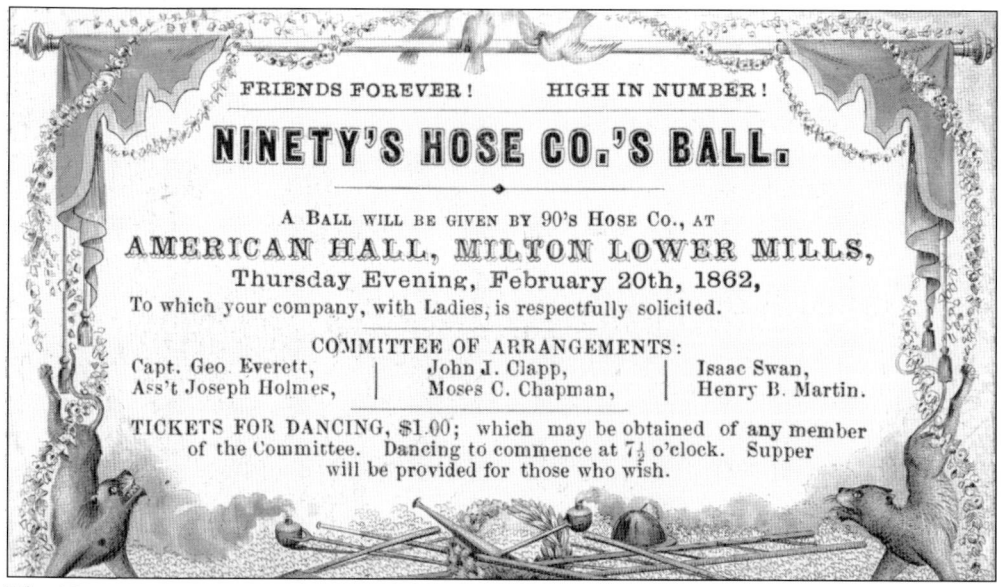

The Ninety's Hose Company was a fire company located in Milton Village beginning about 1848. The Ninety's stored its equipment in a small shed next to the first police station on Wharf Street. Later named Hose No. 3, the company was abandoned by the Milton Fire Department about 1920 and all equipment was sold at auction. This ticket invitation is one of the only artifacts remaining in Milton of this firefighting organization of Milton Village. The ball, held on February 20, 1862, took place at the American Hall located in the village. (Courtesy of the Milton Historical Society.)

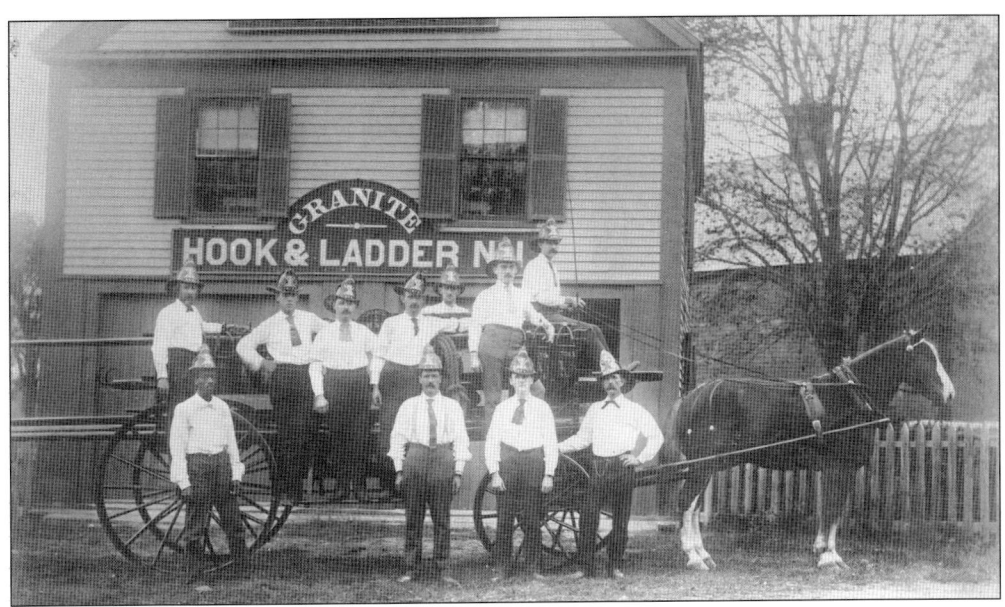

The Granite Hook and Ladder Company No. 1 was formed about the same time as the Hydrant Engine Company No. 1 and shared the engine house in East Milton on Squantum Street near Adams Street. It was later moved to Granite Avenue between Bassett and Antwerp Streets. This photograph from around 1882 shows, from left to right, (first row) William Powell, Michael Barry, John Walsh, and Charles Gardner; (second row) Orin Bates, Thomas Robinson, William Tarbox, James Gallagher, Charles Fish, Charles Wigley, and driver Elias Williams.

The first Union Ball of the Hydrant Engine Company No. 1 and Granite Hook and Ladder Company No. 1 was held in 1886. The affair, held in Milton Town Hall, was reported as a complete success in the local newspaper. Town records of the period recorded that the fire companies were comprised of Hydrant Engine (45 men), Granite Hook and Ladder (25 men), Ninety's Hose (5 men), and Chemical Engine (5 men). Despite an annual stipend of $5, which later rose to $10, these companies should be considered volunteers.

13

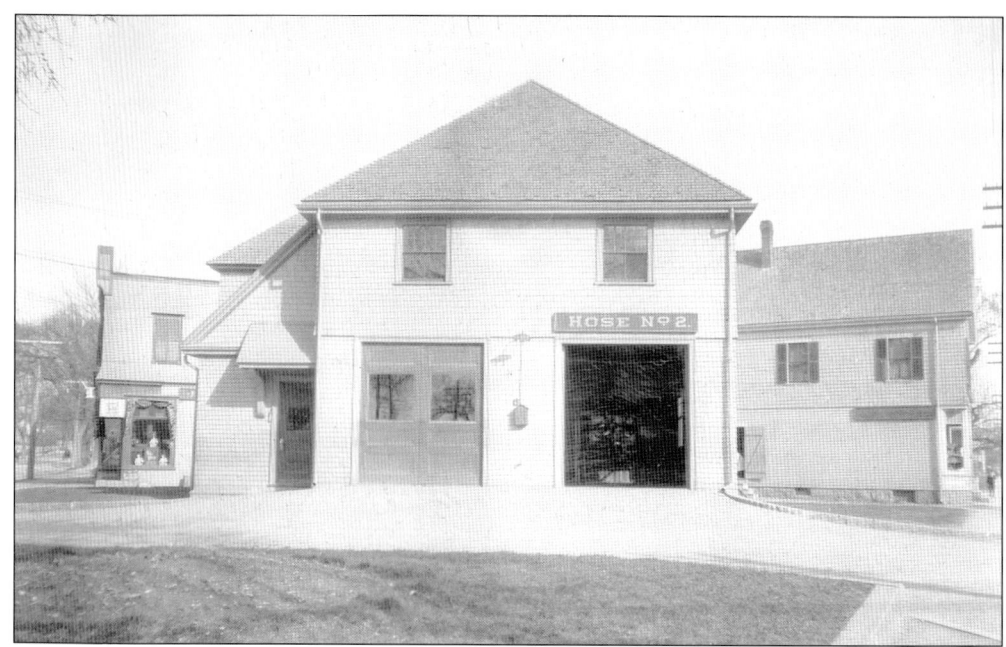

The Hose No. 2 engine house was built in 1893 to replace the older firehouse located on Granite Avenue near the corner of Basset Street. The new firehouse commanded a prominent view of East Milton Square. To the left of the firehouse is Rugby Hall, which still stands and is occupied by On a Roll sandwich shop and Daniel Sweeney's dental office. The site is the same location now occupied by the present fire station in East Milton, built in 1953.

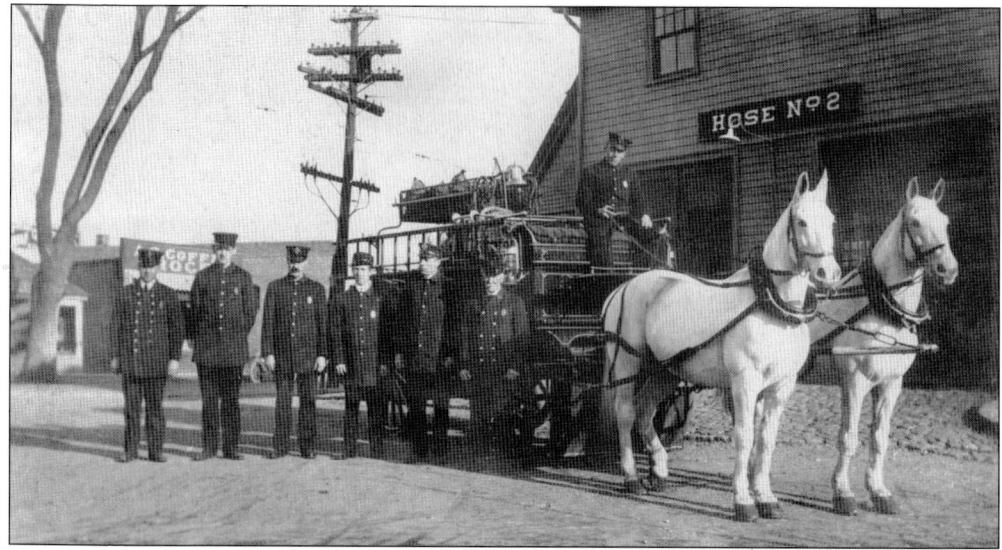

Members of Hose No. 2 gathered for this photograph in front on their new quarters in East Milton at the intersection of Granite Avenue and Adams Streets. The fire station was completed in 1893, and the new hose wagon replaced the old hydrant engine. Hose wagons were extremely versatile engines that could quickly lay hose into steamers, chemical engines, or fire hydrants for the speedy delivery of much-needed water. These wagons carried more than 600 feet of hose and were very common in most urban fire departments of the period. Hose No. 2 was considered an example of a modern fire engine.

Snow has blanketed East Milton and the fire station in this photograph taken about 1900 from the Granite Avenue side of the building. Deep snowfalls presented a difficult challenge to firemen of that period. A heavy snowfall made it difficult, if not impossible, for the horses to pull the heavy equipment over the snow-covered roads. (Courtesy of the Milton Historical Society.)

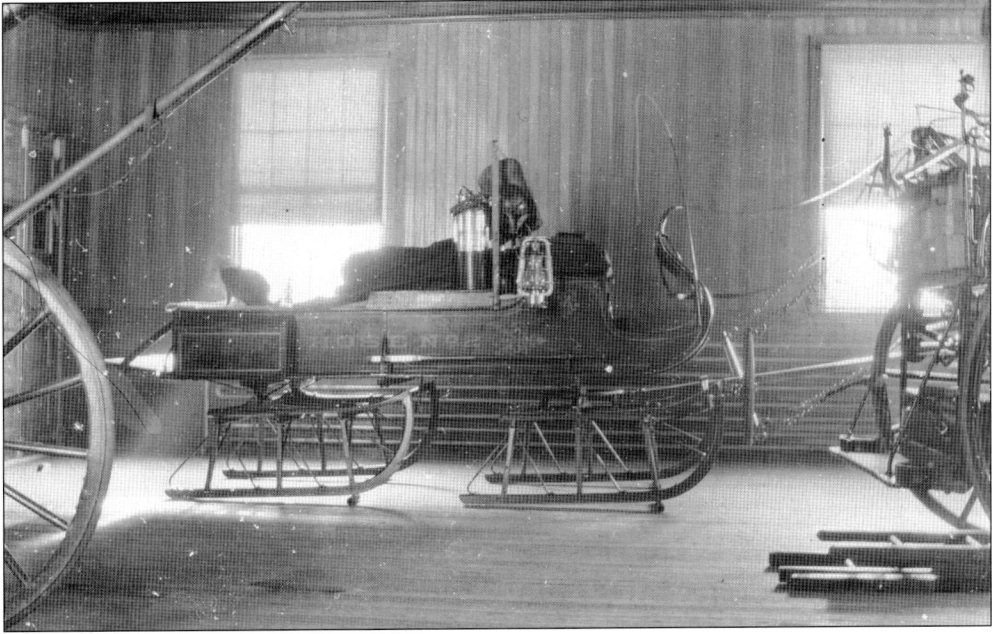

The Hose No. 2 pung, or sled, was used in the winter months when travel through snow became difficult for the horse-drawn wagon. Like the hose wagon, the pung carried all the necessary hose and equipment for fighting fires. In this photograph, a cat is perched atop the rear toolbox looking out the window on to Granite Avenue.

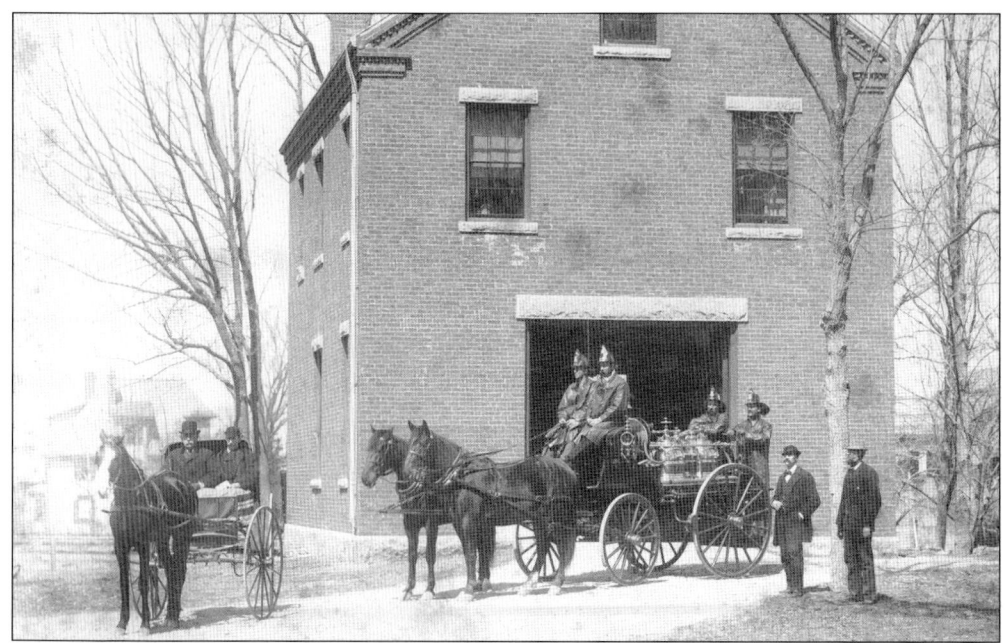

Chemical engine No. 1 was purchased by the town in 1881 and installed in a firehouse built in Milton Center to protect the citizens in that growing section of town. The fire apparatus pictured here was built by the Chicago Fire Extinguisher Company and was state-of-the-art for its time. The new engine was purchased by Milton for $2,000. The firehouse was constructed for the sum of $3,195. William Sias, of Sias Lane, is seated facing forward with the white helmet shield. Sias was a member of the Milton Board of Fire Engineers in the 1890s.

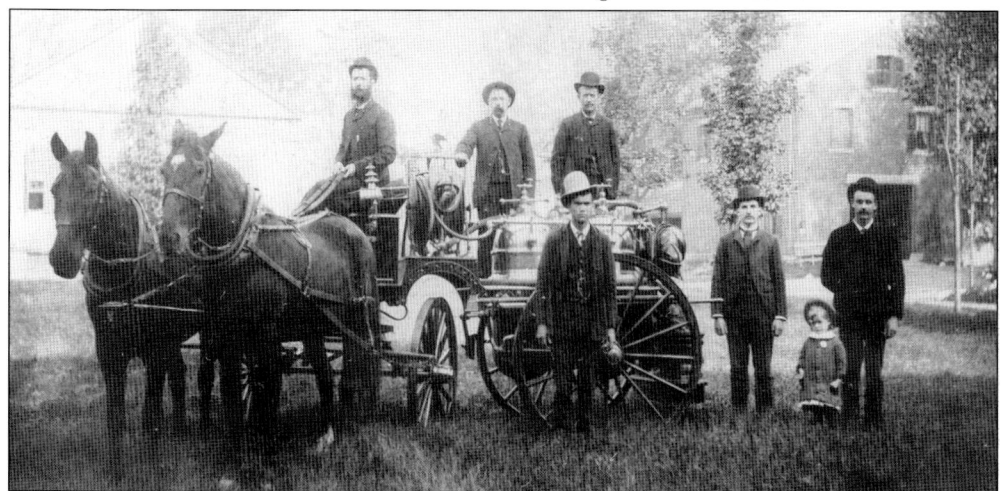

A group of men and a child have come to Milton Center to view the chemical engine and have their pictures taken with the newest addition to the fire department. The chemical engine was the latest innovation in the fire service and was a sign that Milton was taking steps to improve its fire department. Invented in France in 1875, the chemical engine soon became the most common fire engine in America. The chemicals, mostly bicarbonate soda and acid, when added to water created a solution that expelled itself under its own pressure to better extinguish the fire. The child, perhaps a future fire chief, is sporting a badge. (Courtesy of the Milton Historical Society.)

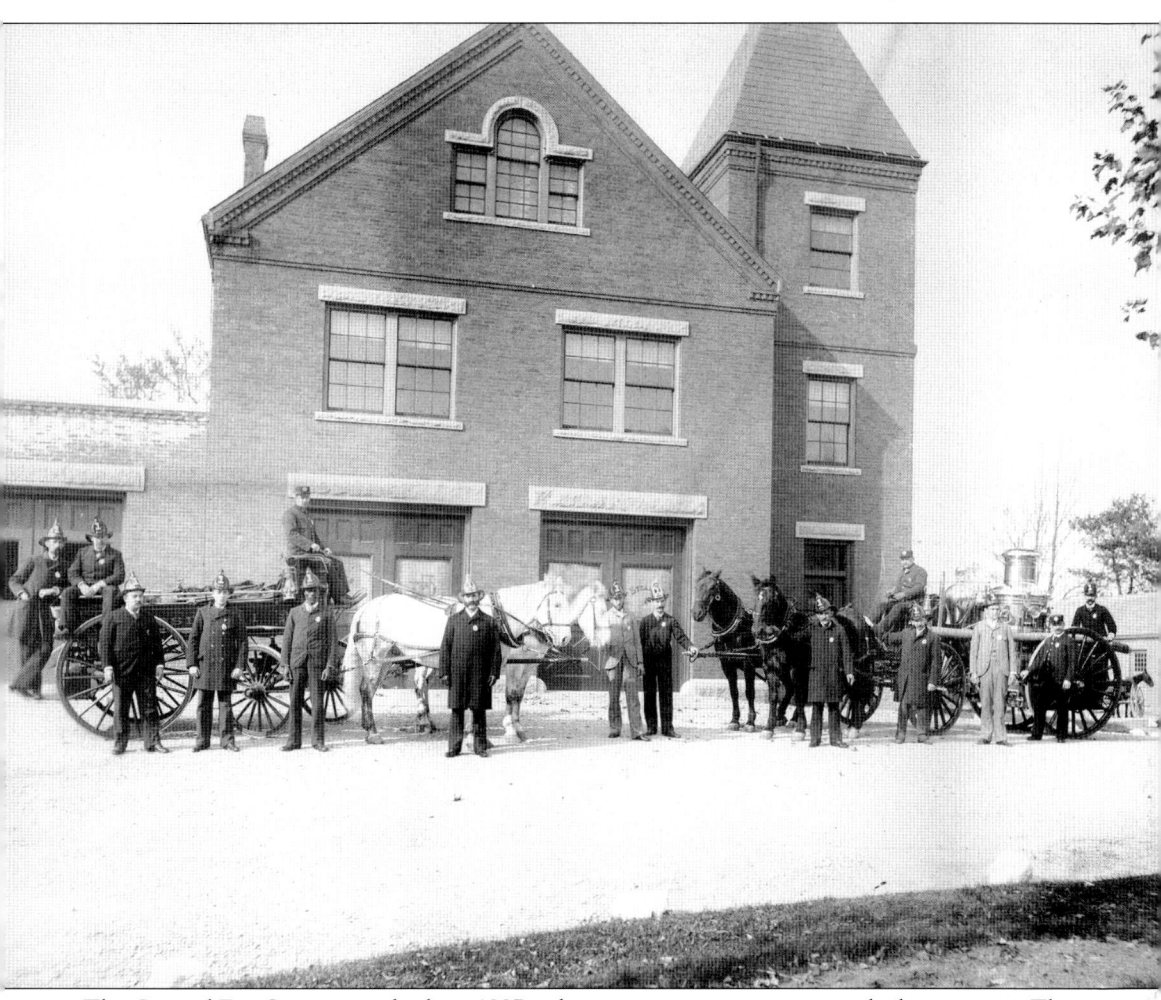

The Central Fire Station was built in 1887 to house a new steam engine and a hose wagon. The steam engine, which was purchased for $3,600, was another example of Milton's commitment to upgrade its fire department. The firehouse was constructed for the price of $7,500. This photograph, taken in 1891, shows the men of hose No. 1 and steamer engine No. 1 in front of the Central Fire Station located behind town hall on Canton Avenue. From left to right are Elmer Nickerson, Henry Holly, Hugh Whitney, C. Wilder Holmes, Elias Williams, Lewis Buckner, Horace Plummer, H. D. Capen, Thomas McDermott, John Ewell, Benjamin Gaul, Charles Bowman, Joseph Pond, Henry Trull, and Eugene Esau.

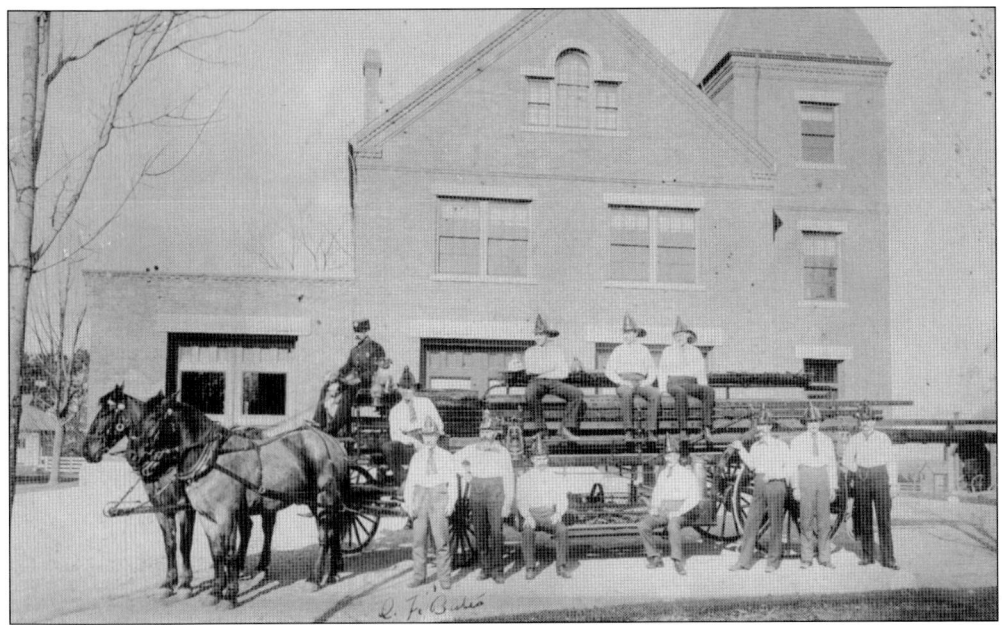

In 1890, the town voted to purchase a new ladder truck at a cost of $1,055. This necessitated a one-story addition to the western side of the Central Fire Station, running the full length of the building, at a cost of $2,788. This photograph, taken in 1891, includes, from left to right, Henry Pierce, the driver with mascot; Thomas McDermott; Orin F. Bates, the foreman; William A. Fredericks; E. W. Hunt (seated above); George H. Joliet (seated below); William C. Lyons (above); H. Franks Hockaday; Christie Whelan (seated); Edward J. Eaton; William W. Chapman; and Everett M. Hickey. The manpower of the Milton Fire Department now consisted of six permanent men, bolstered by 47 call firemen.

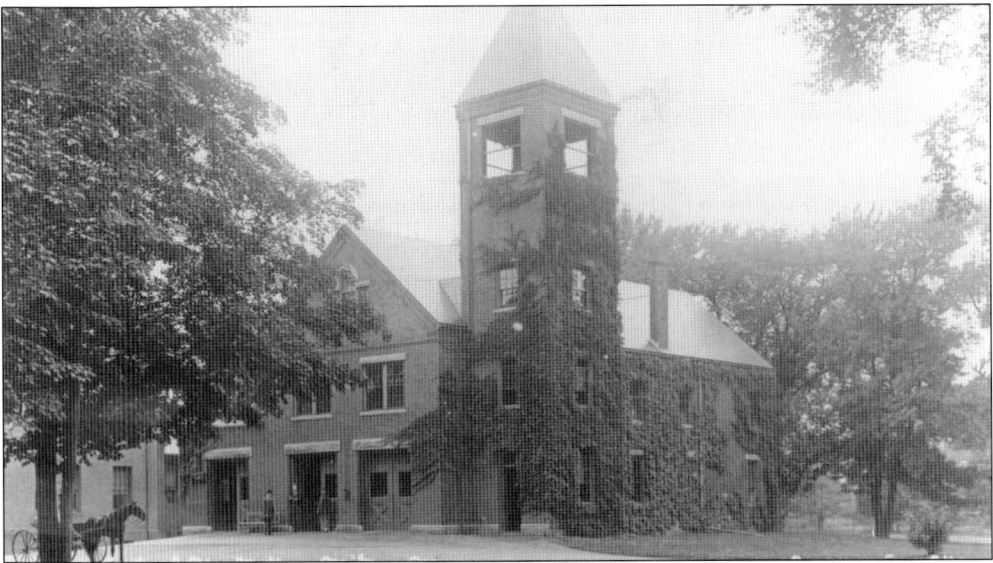

A bell tower was added to the Central Fire Station in 1896 to summon the off-duty and call firemen in times of fire. This photograph, taken about 1900, shows the Vose School beyond the ladder truck bay to the left of the firehouse. The chief's carriage waits out front, ready to respond to the next alarm.

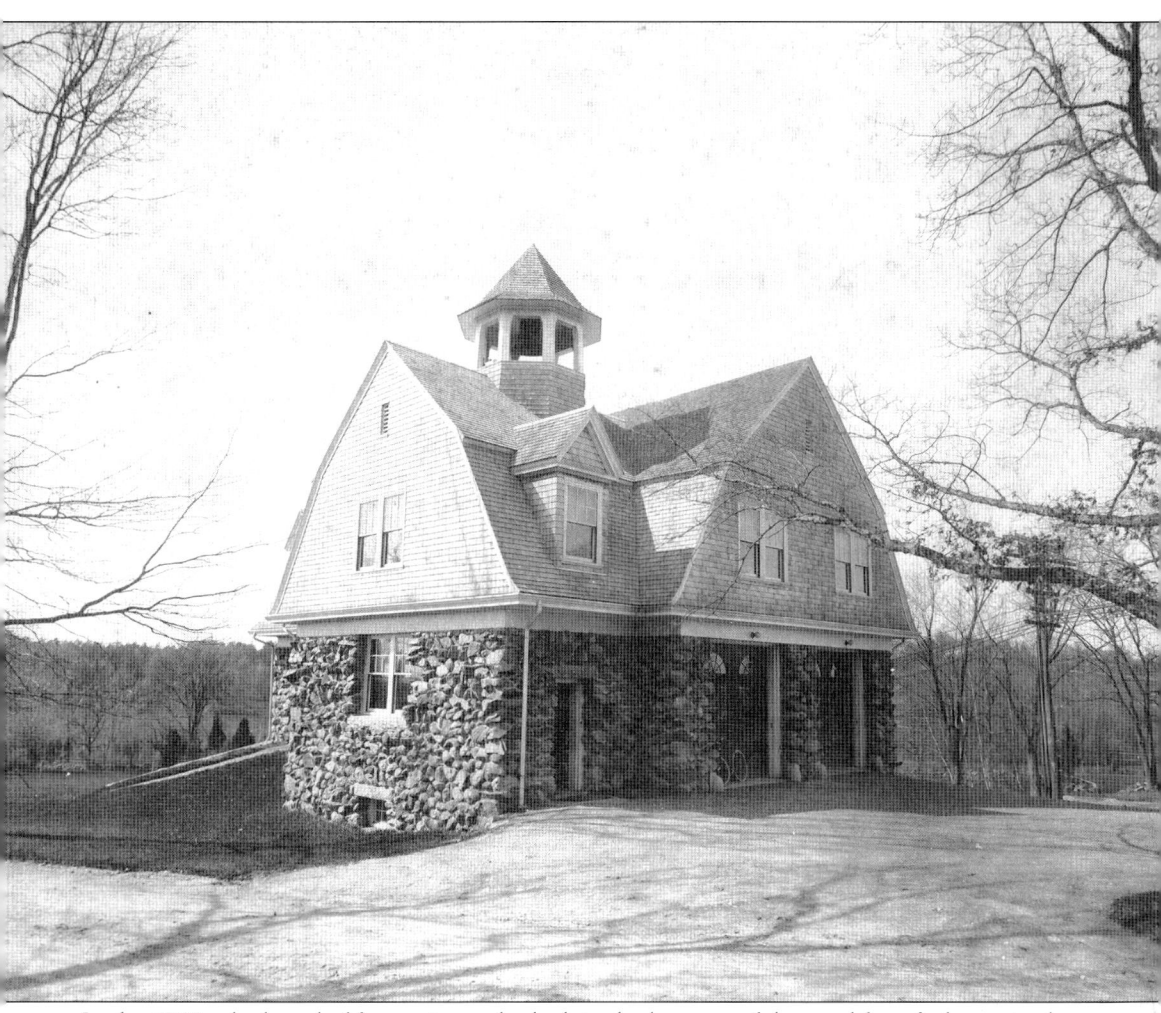

In the 1890s, the board of fire engineers had advised selectmen of the need for a firehouse in the western section of town to address the needs of that growing population. Following the tragic death by fire of a three-year-old child at a residence on Brush Hill Road, Milton selectmen agreed to build the station. The new fire station was constructed in 1901 at the intersection of Atherton Street and Blue Hill Avenue at a total cost of $5,000. A combination chemical and hose wagon was installed at the station, and two permanent men were assigned there. The site was chosen because of its central location in the district at the junction of a busy intersection.

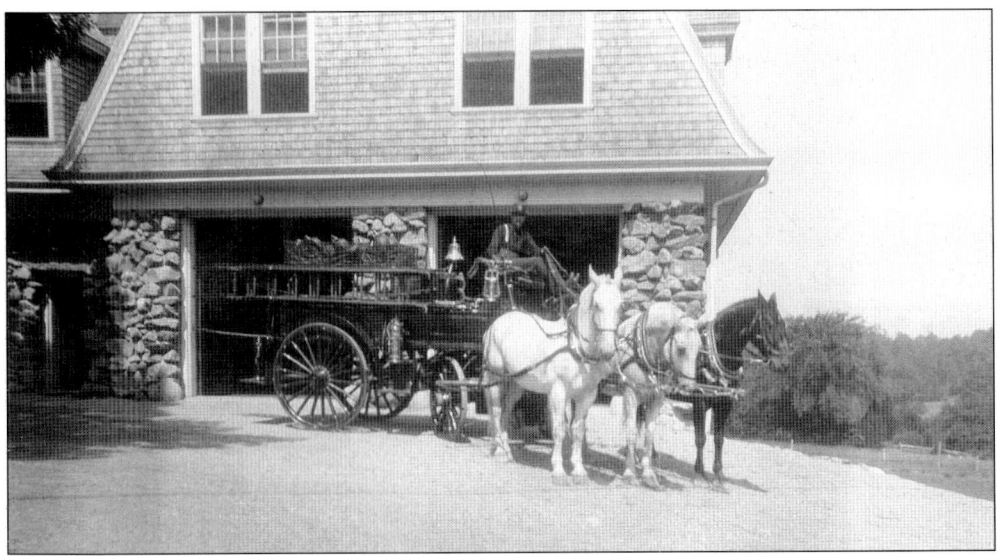

Hose No. 4 was installed in the new firehouse in 1901. The hose wagon carried about 600 feet of hose and proved a useful tool that could hook up to a hydrant to supply water to the steam pumper or work from a hydrant under its own pressure. The wagon was also equipped with twin 30-gallon chemical tanks and hose. Other essential firefighting tools such as nozzles, axes, wrenches, and firefighters' gear, including helmets and turnout coats, were carried on top. Now a firehouse was situated in all populated sections of the Milton community.

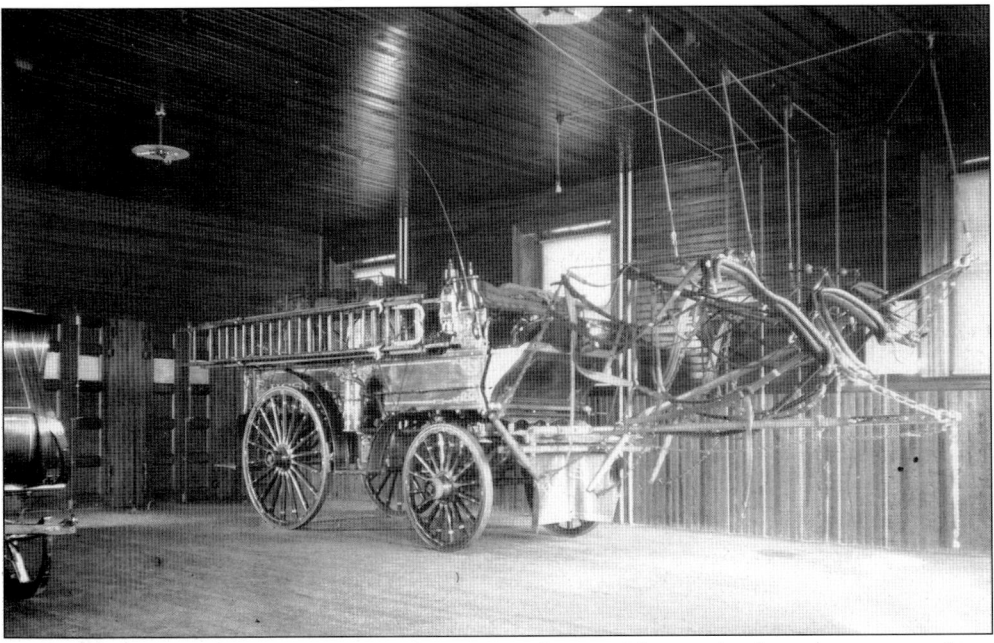

Hose No. 4 wagon sits idle in quarters but prepared to go. The quick-release harness machine attached to the ceiling was developed for fire stations in the 1870s, making it easier to get out quickly. On hearing an alarm of fire, the horses were trained to take their places beneath their harnesses, and a fireman would pull the quick-release cord, dropping the harnesses upon their backs. After strapping the horses in, off they would go. Hose No. 4 pung sits idle nearby, ready for the next winter's snowfall.

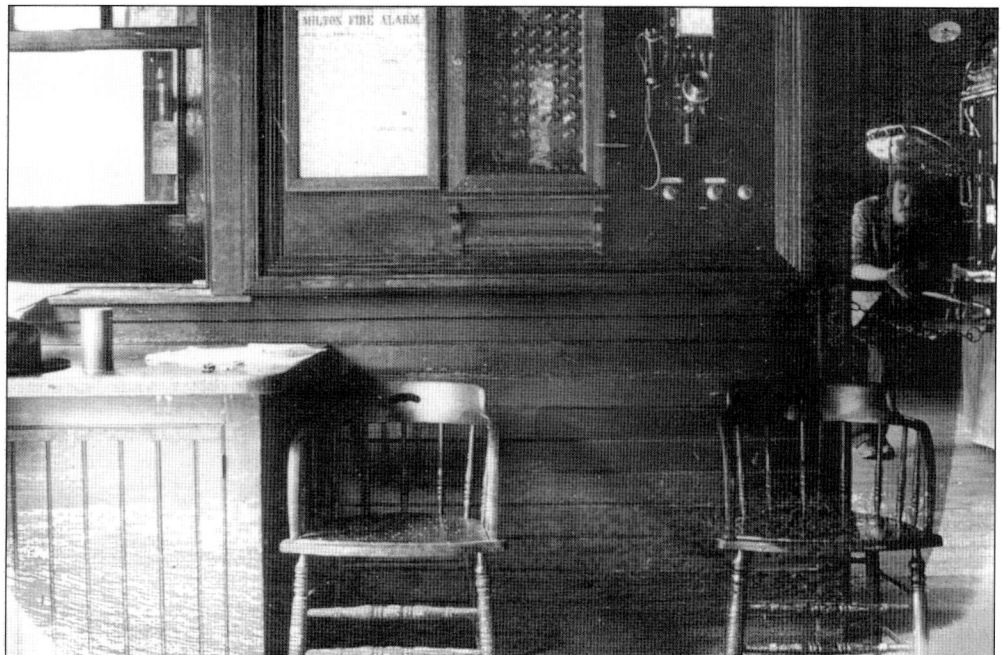

This photograph shows the fire alarm receiving station at the Central Fire Station in Milton about 1900. In 1893, a telephone was added and an arrangement was made with the Boston Fire Department to summon help by telephone when necessary. Previously a runner had to be sent to the Dorchester firehouse on River Street in Lower Mills when help was needed. (Courtesy of the Milton Historical Society.)

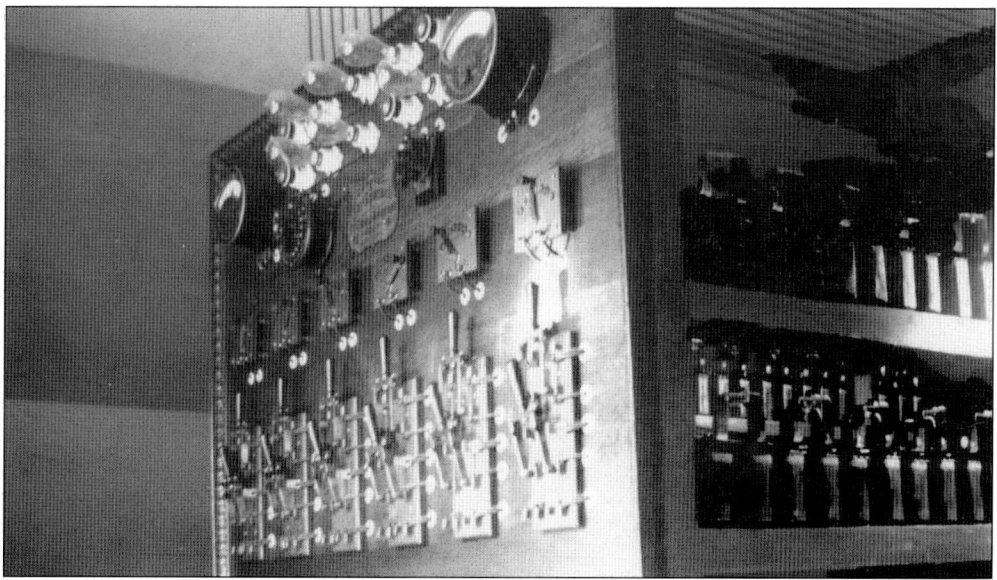

Fire alarm systems were developed for fire departments as early as the 1850s with the development of the telegraph. This early example of a fire alarm receiver/relay device was located in the Central Fire Station and photographed by Milton fireman Ernest Choate (1877–1933). Choate, together with his father, Fire Chief George Choate, developed the Milton Wire Department, which he headed from 1913 until his death. (Courtesy of the Milton Historical Society.)

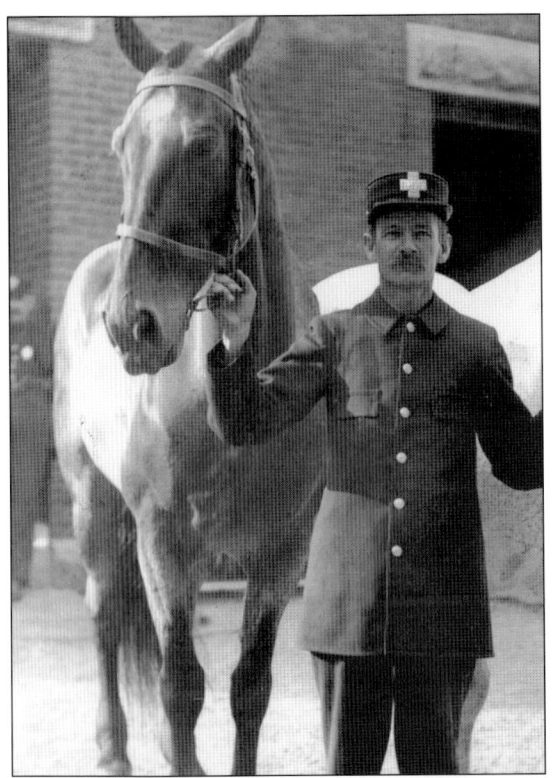

Milton fireman William J. Hicks handles his team outside the ladder truck bay at the Central Fire Station in Milton Center about 1900. The feeding, cleaning, and exercising of the horses was a daily routine of all Milton firemen in this period. The last horse was retired by the fire department in 1919, although horses were sometimes hired during heavy snowfalls. (Courtesy of the Milton Historical Society.)

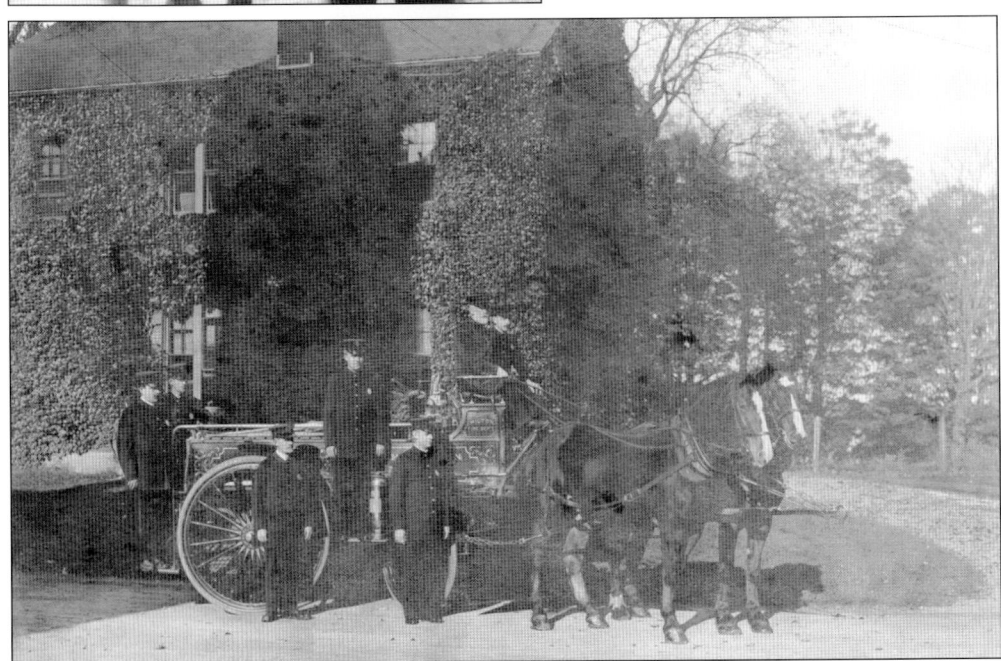

The men of Chemical Engine No. 1 of Milton pose with their engine next to the ivy-covered Chemical Engine House in a photograph taken in approximately 1910. This newer-style wagon replaced the older model first introduced in Milton in 1881. The roster of the Milton Fire Department in 1910 included 12 permanent and 44 call firemen.

# Two
# THE FIREMEN AND THEIR MACHINES

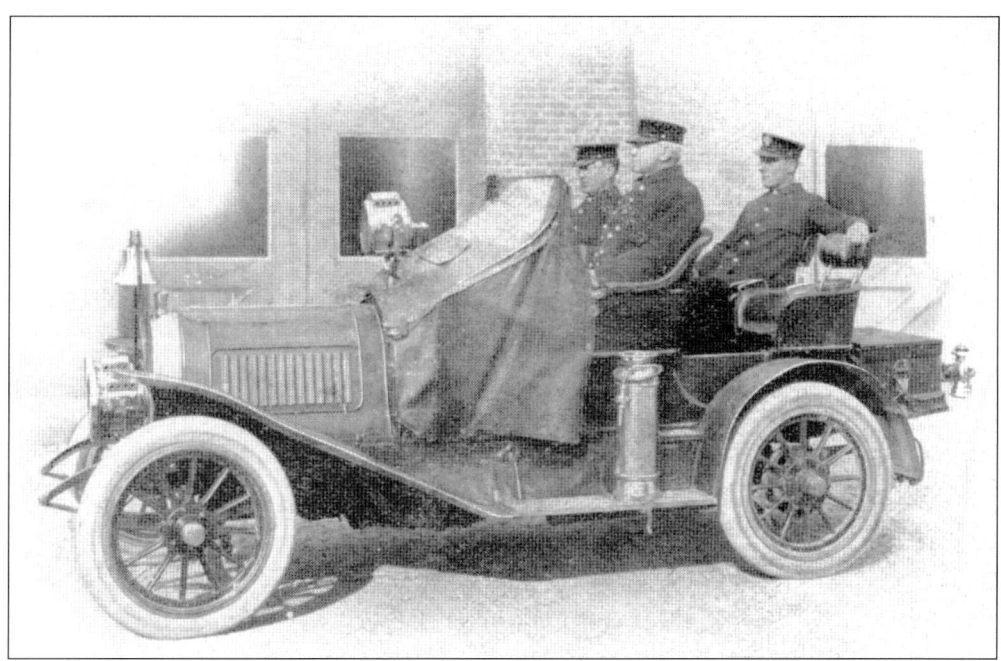

The Milton Fire Department began its motorization in 1909 with the purchase of this Pope-Hartford automobile for the fire chief. After the automobile was outfitted with a chemical tank and hose basket in 1914, it was recognized as Milton's first motorized fire apparatus.

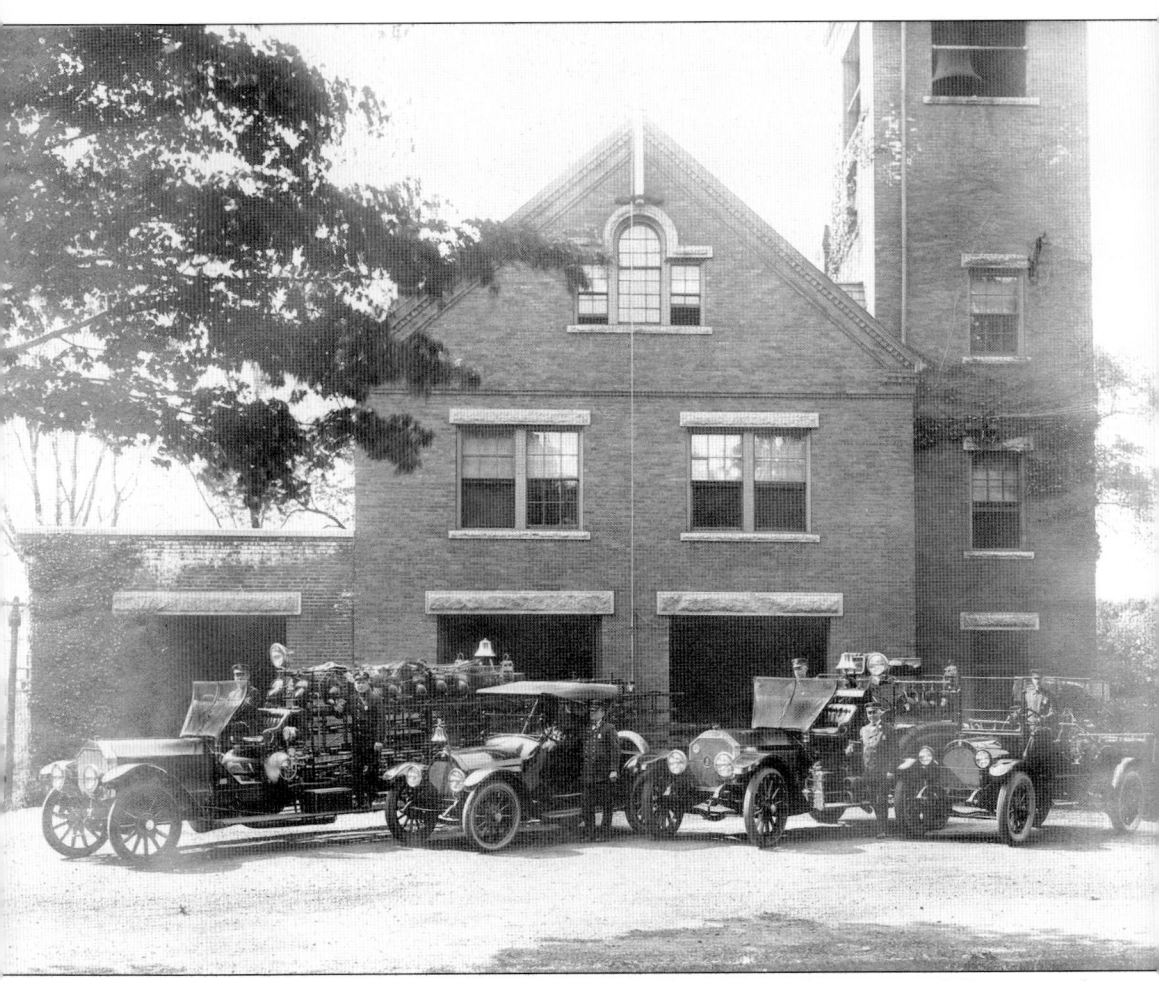

The Central Fire Station, located behind the town hall on Canton Avenue, was fully equipped with motorized apparatus by 1920. Fire Chief J. Harry Holmes is standing next to the automobile. Capt. James Hanna is standing next to engine No. 1. To the far right is the 1919 Oldsmobile truck that had been converted into a chemical fire engine by the firemen of Milton. This truck was fully restored in the 1990s and is now part of the Milton Firefighter's Memorial Archives collection. Milton ladder No. 1 is on the far left. The fire department was now comprised of 15 permanent and 32 call firemen.

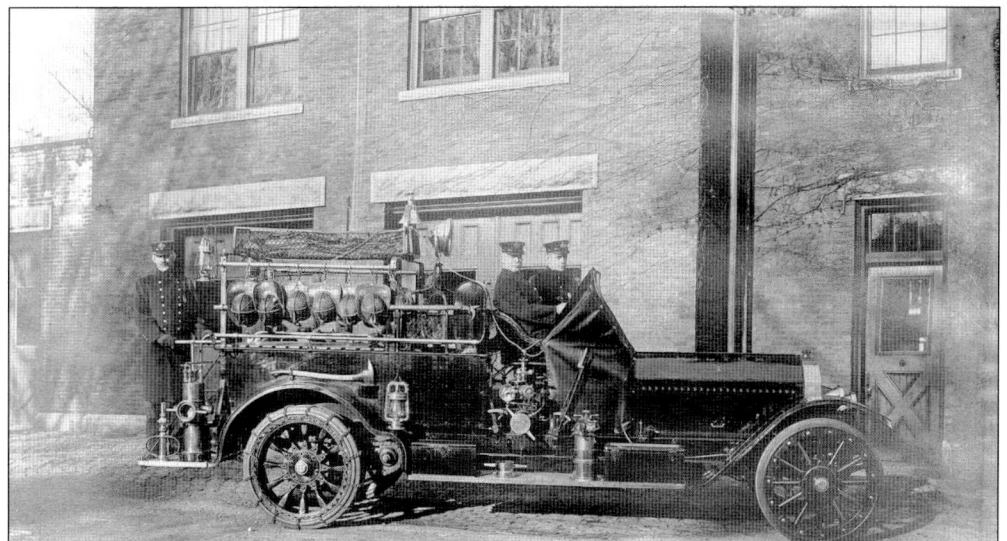

Engine No. 1, a 1918 American LaFrance, was a combination chemical engine and pumper. Chemical fire engines were still the rage in the American fire service and more so now that they could be driven even faster to the fires. Following a barn fire on Brush Hill Road in 1919, Chief J. Harry Holmes reported to selectmen that the engine performed remarkably well, pumping water for more than six hours without stopping. William J. Hicks is pictured on the back step of the engine with his hand on top of a portable fire hydrant.

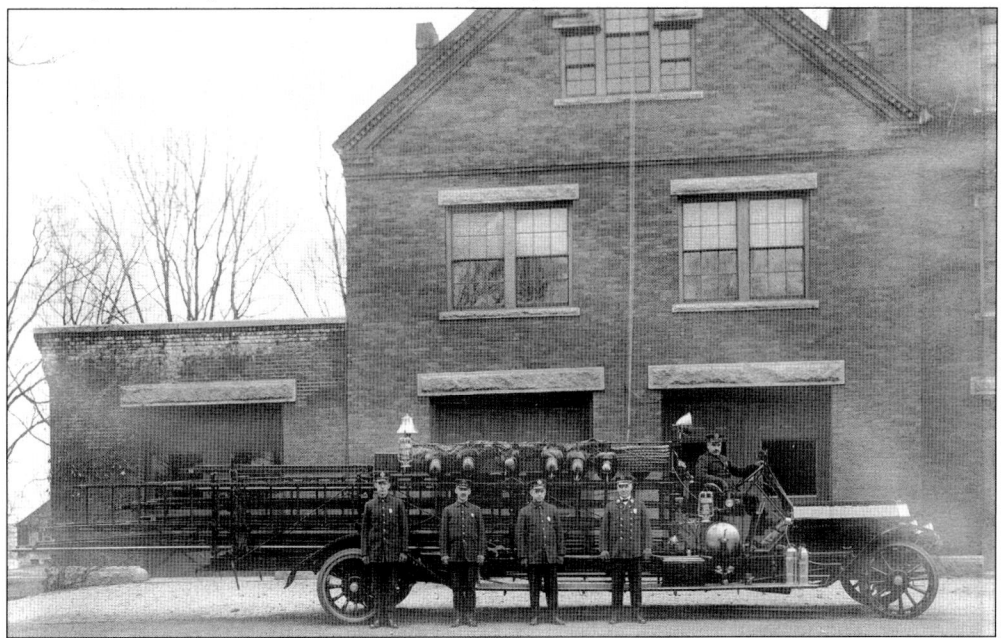

Milton firemen pose with their 1916 American LaFrance ladder truck in front of the Central Fire Station in Milton Center. Besides ladders and other firefighting equipment, this versatile truck was equipped with two chemical tanks and hose. American LaFrance began manufacturing fire apparatus in 1872 in Elmira, New York, and was the number one fire apparatus manufacturer in America for many years. In 1916, a number of Milton firemen were sent to Elmira to receive instructions in the operation of the new fire engines.

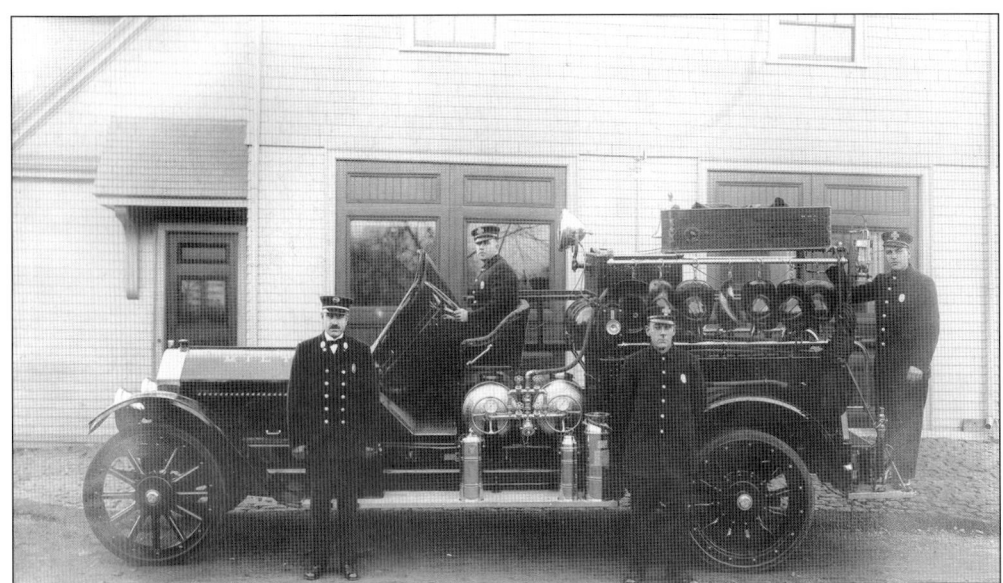

American LaFrance engine No. 2 was a combination chemical and hose wagon. During this period, it was claimed that chemical fire engines extinguished more than 80 percent of the fires in America. They were useful mostly because they could arrive quickly before the fire grew out of control. Their biggest limitation was that they could only carry 70–80 gallons of chemical solution, which could not handle the larger fires. Besides the chemicals, the engine carried more than 600 feet of supply hose. Pictured in this image from left to right are firemen John Tolman, an unidentified driver, James Craig, and Joseph Shields on the back step of the engine.

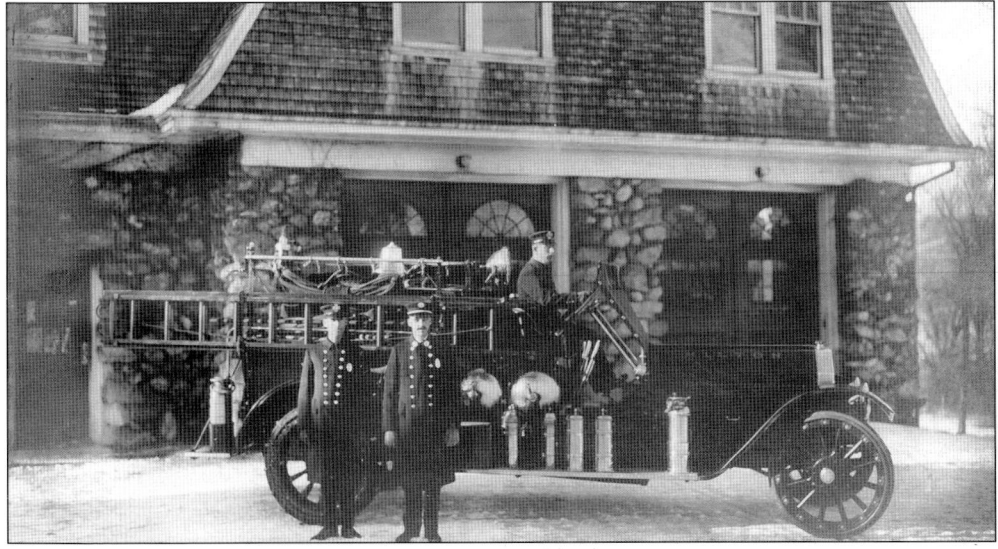

This American LaFrance chemical fire engine replaced the horse-drawn hose No. 4 in 1916. Chemical fire engines continued to be very popular with most fire departments in the United States until the Ahrens/Fox Company developed a pump that could be operated at the fire scene by the truck's engine. Manufacturers began making fire trucks outfitted with these pumps, supplemented by large water supply tanks. This innovation allowed water to be dispersed onto the fire in greater volume and faster than the chemicals. The chemical fire engine soon faded into history.

Ernest Choate (1877–1933), son of Milton fire chief George Choate, began his career with the Milton Fire Department at the age of 15. He was technically gifted and worked with his father to create a fire alarm system for the Milton Fire Department. He became Milton's first wire inspector in 1913. He was also a gifted photographer. Many of his photographs, including some that appear in this book, document the Milton Fire Department from 1895 to 1905. (Courtesy of the Milton Historical Society.)

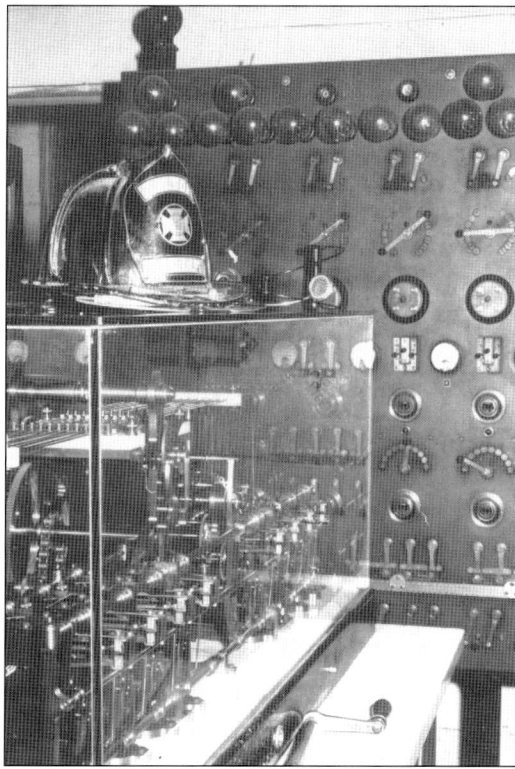

In 1921, an addition was made to the rear of the Central Fire Station, and this updated fire alarm circuit board and repeater were installed under the direction of Ernest Choate, the Milton wire inspector. The circuit board in the background received the alarms, and the repeater in the foreground relayed the signals to the other fire stations, alerting the firemen of an alarm of fire. This equipment continued in service in Milton until it was replaced by a modern system in the 1980s. This photograph was taken about 1975 when the system was still in use.

Fireman Charles Stuart operates the 1930 Chevrolet fire engine that replaced the 1919 Oldsmobile combination wagon at the Central Firehouse. In his annual report to selectmen, Chief J. Harry Holmes reported that the new Chevrolet wagon had responded to a large number of calls since being placed in service and performed very satisfactorily.

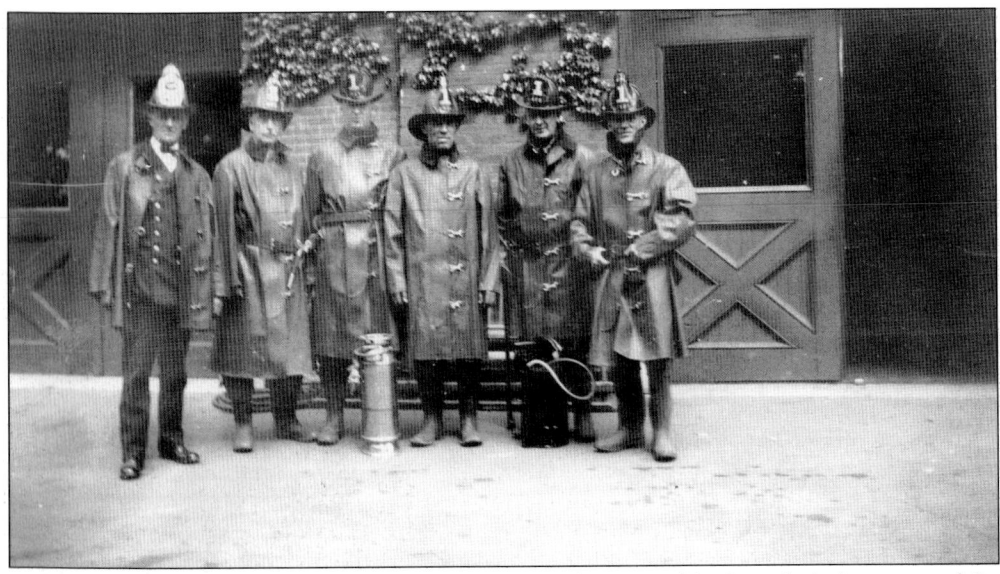

Milton firemen with fire extinguishers, rubber coats, boots, and high eagle helmets posed for this photograph in front of the Central Fire Station about 1930. The group includes, from left to right, Lieutenant Williams, two unidentified firemen, Mickey Donohue, Charles Stuart, and Ashton McLeod.

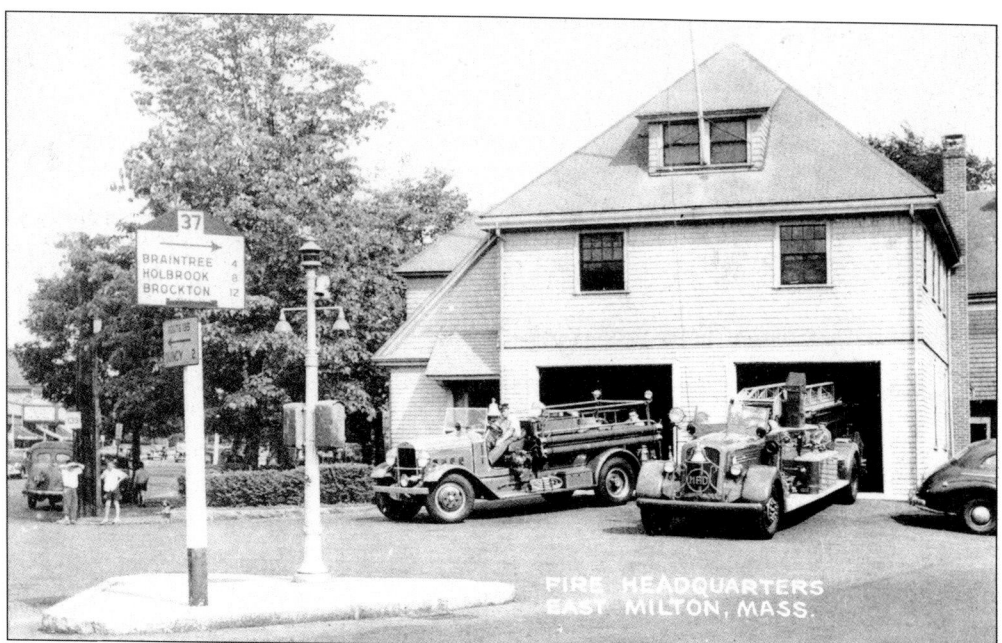

This postcard shows the East Milton fire station about 1945. On the left is engine No. 2, a 1934 Maxim pumper manufactured by the Maxim Fire Corporation of Middleboro. A new 65-foot aerial ladder truck built by the Seagrave Corporation was placed into service there in 1943. This was the first ladder truck in service in East Milton since the Granite Hook and Ladder Company was disbanded in the 1890s.

The aerial ladder of ladder No. 2, a 1943 Seagrave, is extended for this practice drill in front of the firehouse in a photograph taken about 1945. The fireman at the end of the ladder is Robert Tucker. Tucker's son, Capt. Robert Tucker of the Dennis Fire Department, submitted this photograph in memory of his father. (Courtesy of Robert Tucker.)

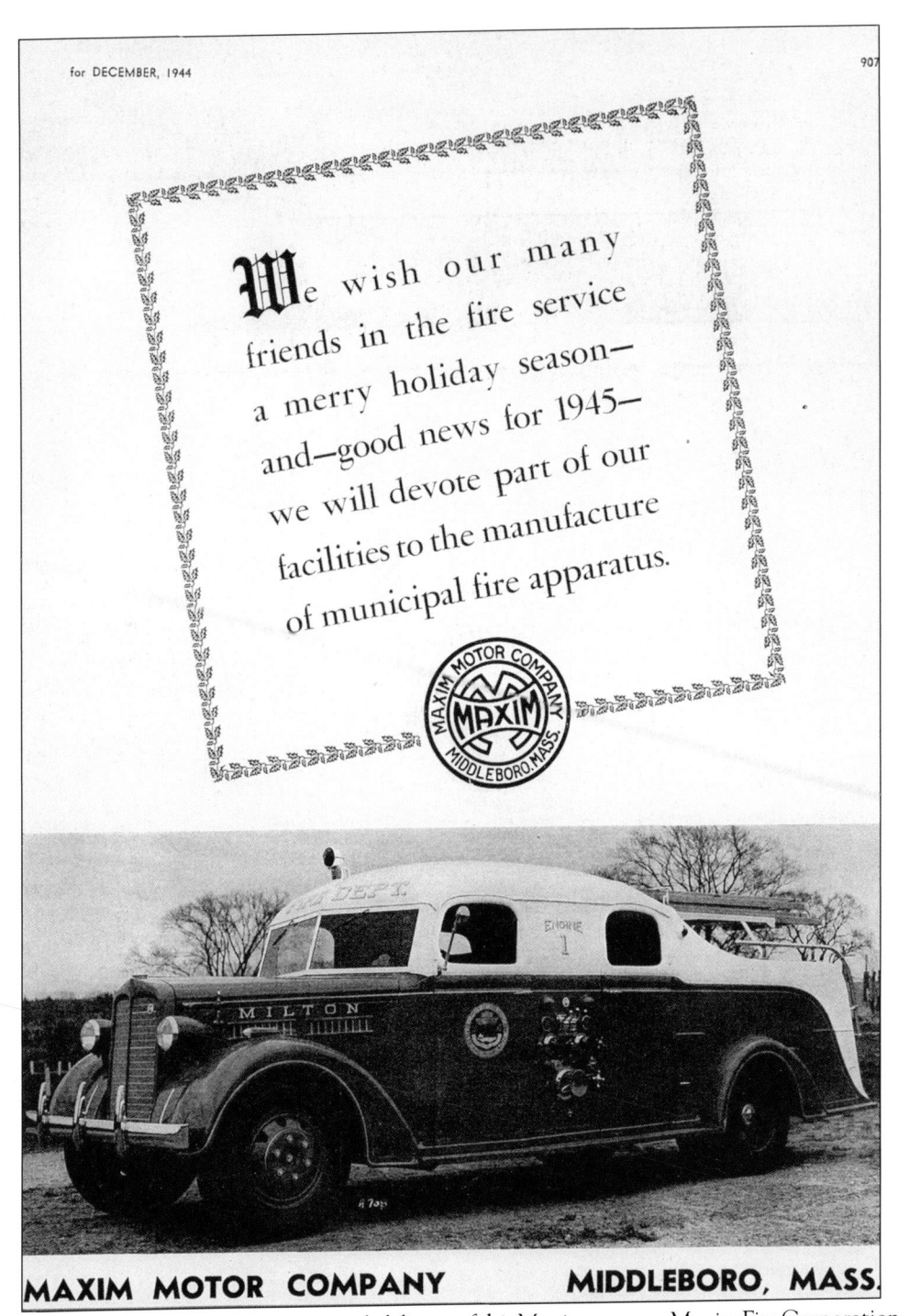

In 1941, the Milton Fire Department took delivery of this Maxim pumper. Maxim Fire Corporation, located in Middleboro, was proud enough of this model to use it in this advertisement of 1944. Maxim was a very popular fire apparatus manufacturer, especially with fire chiefs in the New England states. Known for its quality workmanship and attention to detail, Maxim stopped manufacturing fire apparatus in the 1980s and is now completely out of business.

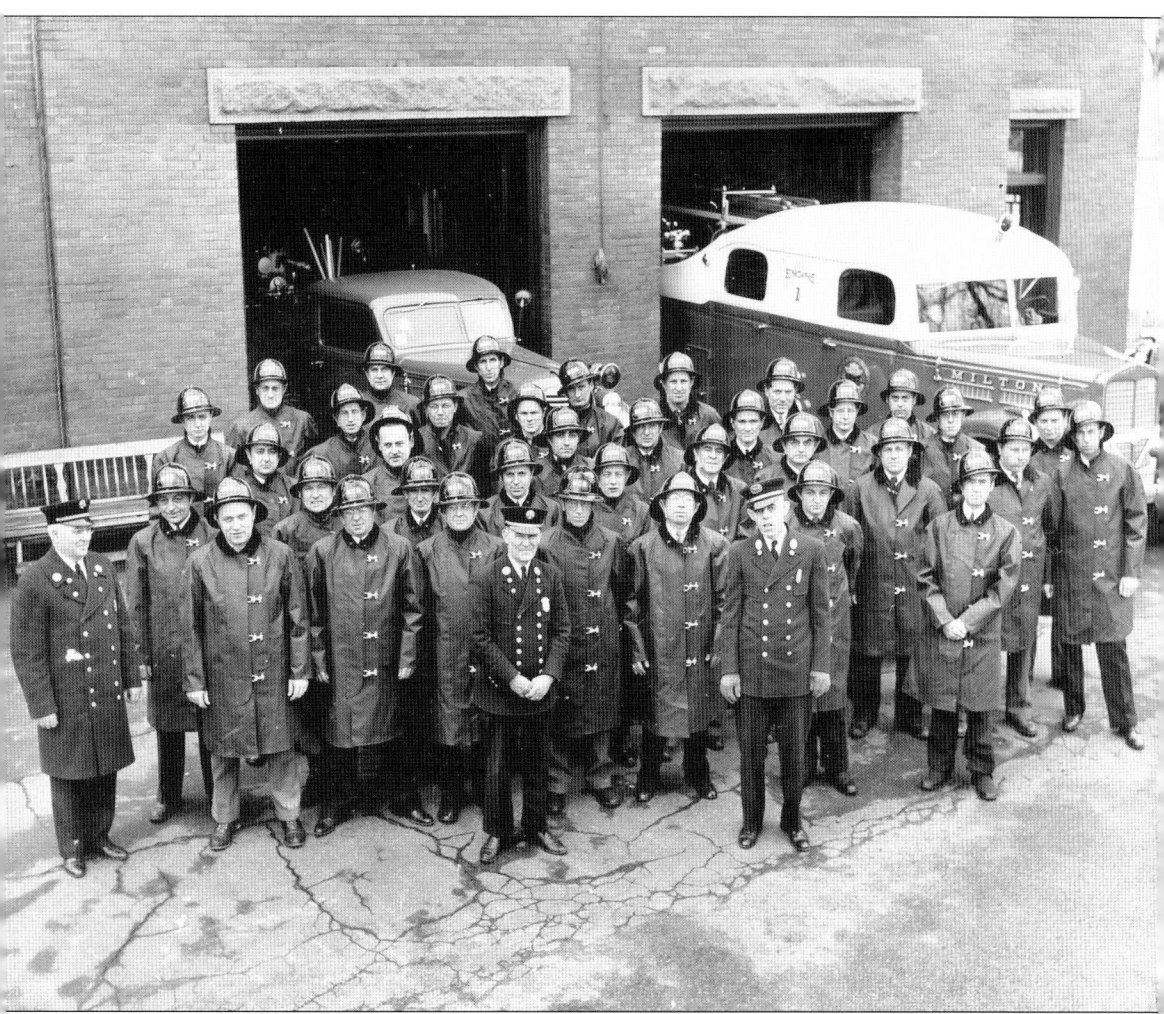

Dubbed "Milton's answer to Hitler" in the local newspapers, Milton Civil Defense members gathered in front of the Central Fire Station for this photograph taken in 1941. To supplement the manpower shortages created by the national emergency of World War II, these men were trained to aid the fire department when necessary. They practiced air raid drills and were trained in firefighting and first aid skills. The men built three portable water pumps for emergency water supply for the fire department or public use. This organization later became the Milton Auxiliary Fire Department. The fire officers in dress uniform are, from left to right, Fire Chief James Hanna, Deputy Fire Chief Ashton McLeod, and Lt. Frederick Whelan.

# AIR RAID PRECAUTIONS

Preliminary A.R.P. instruction for Milton Residents issued by the
MILTON COMMITTEE ON PUBLIC SAFETY

## AIR RAID ALARM

I. Until replaced by air raid sirens, the Milton air raid alarm is the fire whistle and bell giving a 1-2-3-4 signal repeated four times. All Clear is one long blast.
II. If the air raid alarm is sounded
    a. Stay at home or in any house or building where you may be.
    b. Seek shelter indoors immediately if you are in the street.
    c. Keep away from windows. Glass may be shattered.
    d. Be sure that your car is parked so that it won't obstruct the road.
    e. Except in an emergency, do not use the telephone.

## FIRE PROTECTION

I. Attics and cellars should be cleared of all inflammable material such as boxes, newspapers, etc., especially under eaves.
II. Keep two buckets of dry sand and a shovel in the attic. Do not use water or fire extinguisher on incendiary bombs. Throw sand on bomb, and use water only on surrounding fire.
III. Have a stirrup pump or a hose with a connection to fit an indoor faucet.
IV. Entering a smoke-filled room, keep low. Lie down and crawl. There is oxygen six inches from the floor.

## FIRST AID FOR BURNS

I. Apply bandages soaked in solution of 2 to 3 heaping tablespoons of baking soda dissolved in a quart of water. Bandage lightly and keep damp.
II. Black tea steeped in hot water, applied cool.
III. Tannic Acid Jelly or Amertan, sold in tubes at drugstores.

## AIR RAID PRECAUTIONS

I. Know the location of your electricity, gas and water shut offs, and instruct every member of the household how to operate them.
II. Electricity: Shut off switch handle should have leather strap or cord to avoid shock when turning off current.
III. Gas: Keep shut off wrench handy.
IV. Water: Fill buckets, tubs and containers in case water should be shut off.
V. Your local air raid warden has been trained for war emergencies. Go to him for help or information on how to protect your home.

## KNOW YOUR LOCAL AIR RAID WARDEN

These civil defense air raid warning instructions were sent to every household in Milton during the war years. They were meant to aid those who chose to stay at home or were unable to reach one of a number of designated fallout shelters in the town. Civil defense air raid drills were practiced periodically in Milton during the war years and after. An air raid warning siren is still mounted on the roof of the East Milton fire station.

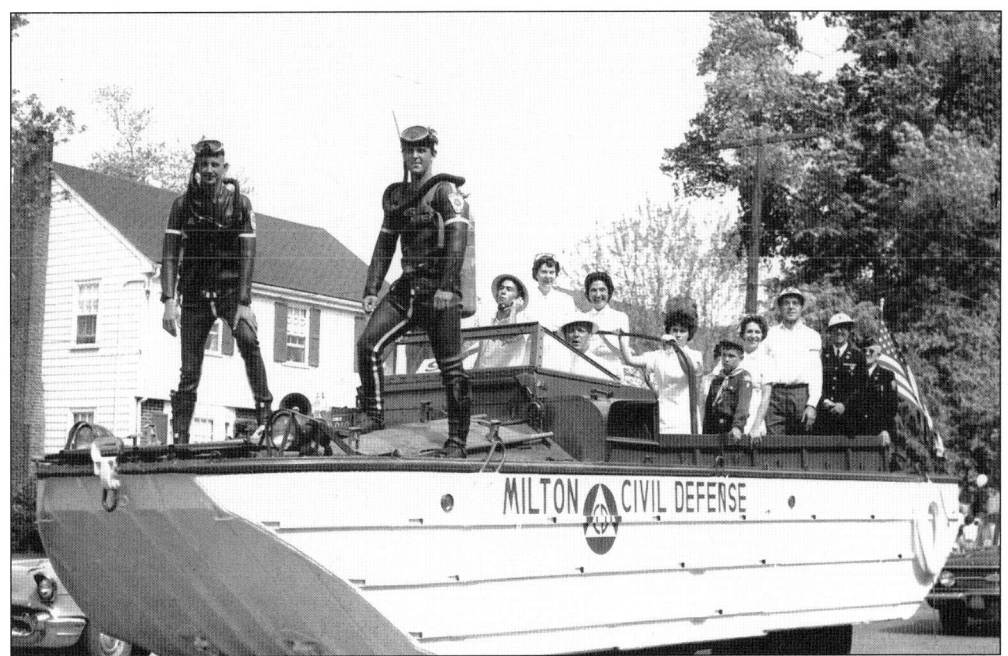

The civil defense amphibious vehicle, or "duck boat," was a popular attraction at the tercentenary parade held in Milton in 1962. These auxiliary fire department members were trained in scuba diving and water rescue and were ready to respond in times of emergency. The air raid wardens with their communication devices are seen in the rear of the vehicle.

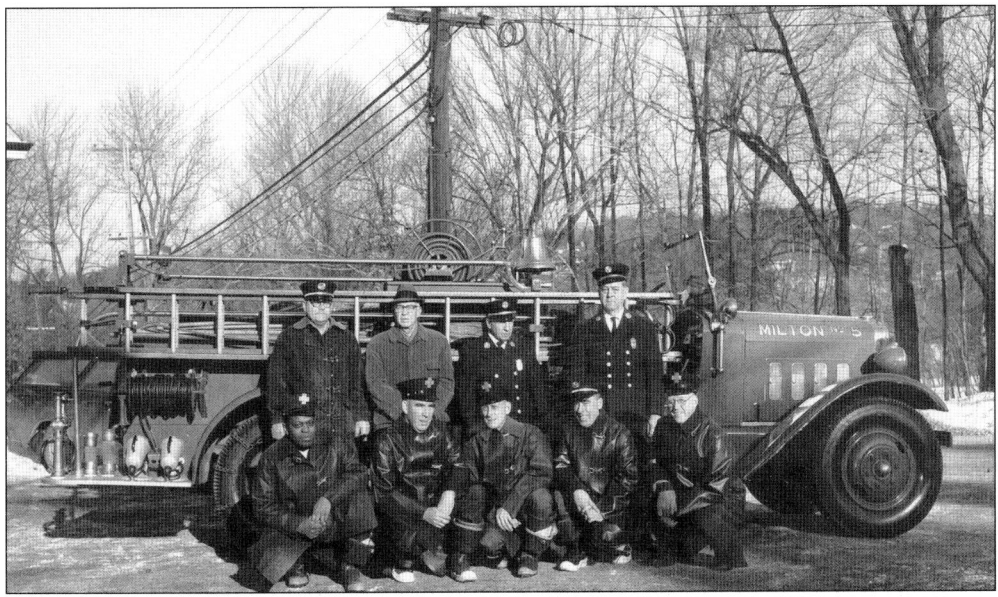

Members of the Milton Auxiliary Fire Department pose in 1968 with the 1934 Maxim pumper. Pictured from left to right are (first row) Benjamin Coleman Jr., W. Dowling, Richard Forbes, Lt. H. Malone, and Edward Wendall; (second row) Capt. Lawrence Pickard, Harold Patterson, Fire Chief Lewis Lyons, and Deputy Fire Chief Robert Ochs. The care and maintenance of the antique fire truck for parades and other community events has become a major responsibility of the auxiliary fire department.

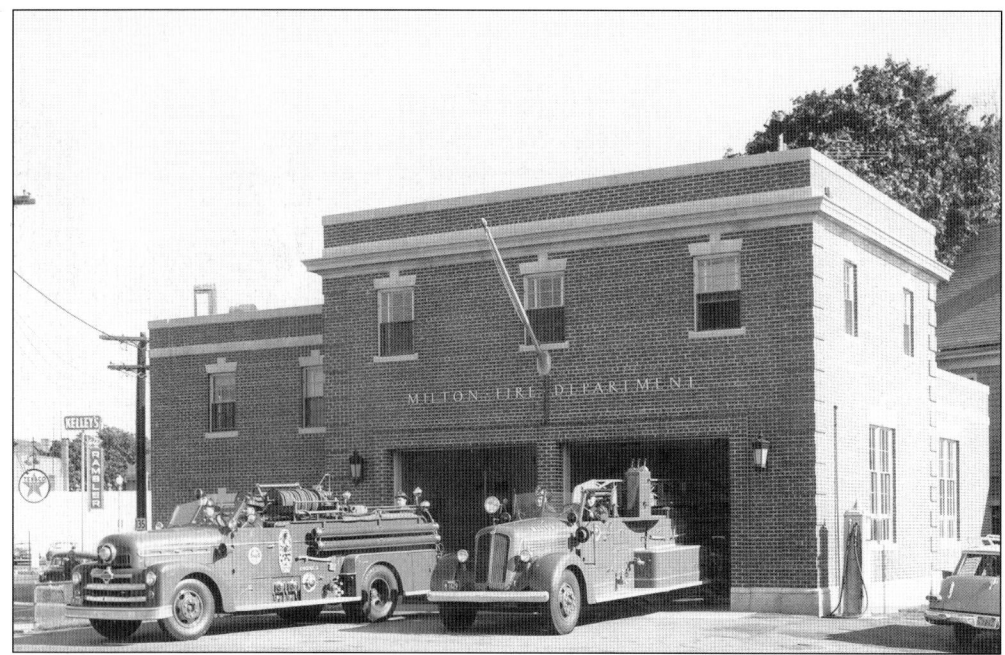

The new East Milton fire station was built in 1953, replacing the old Hose No. 2 engine house of 1893. Engine No. 2, on the left, was a 1,000-gallon-per-minute pumper built by the Seagrave Corporation in 1953, and the 1943 ladder No. 2 truck with 65-foot aerial ladder is on the right. Kelly's garage and Rambler car dealership can be seen on the left. This is where the fire department housed its equipment while construction on the new firehouse lasted, a period of about one year.

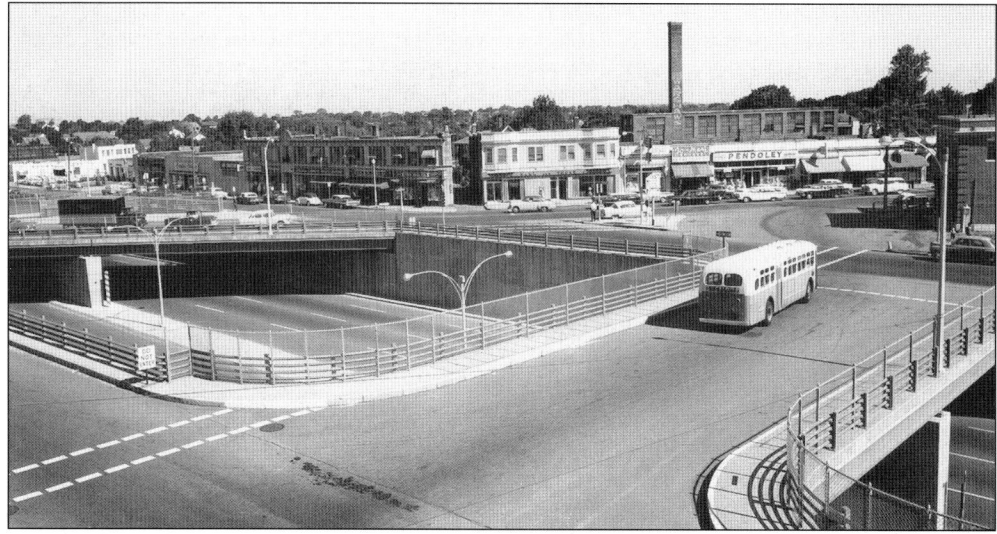

This view of the Southeast Expressway, constructed through East Milton in 1953, shows the tremendous growth of the area and a new responsibility for the fire department. The firehouse is situated on Granite Avenue, alongside the expressway between exits 10 and 11, and the fire department has routinely responded to accidents, fires, and medical emergencies on the highway ever since it was constructed. The depressed highway has been nicknamed "the hole" by members of the fire department. This photograph was taken about 1954.

The Milton Fire Department marched in the 300th anniversary parade of the town held in 1962. Seen leading the department in the march up front is Fire Chief Lewis Lyons. Milton firefighter John McSharry bears the American flag. In the 1960s, the call fire department was completely disbanded, and manpower topped out at more than 60 permanent firemen including the chief.

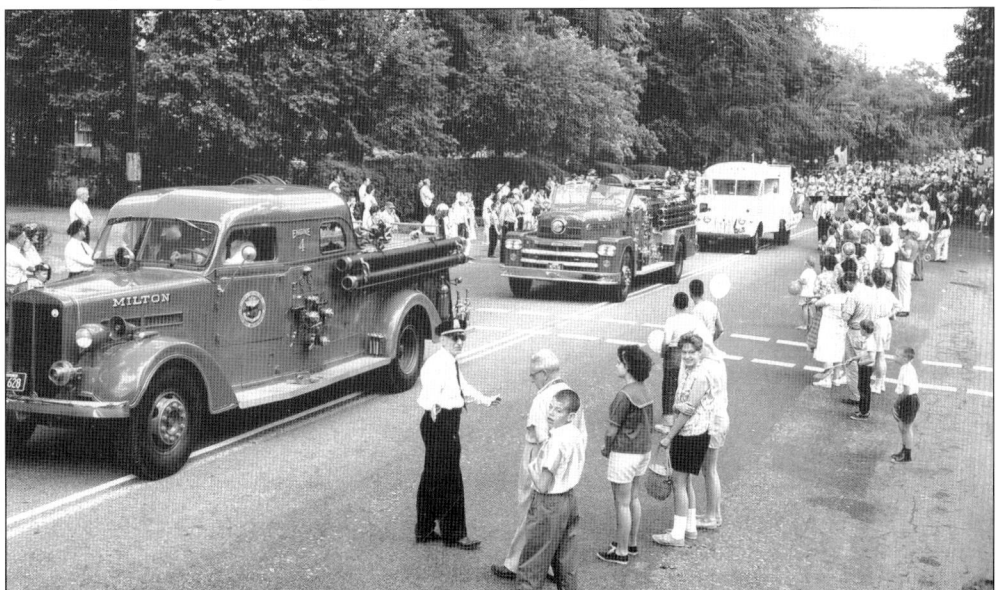

Behind the marching firemen are engine No. 4, a 1944 Maxim pumper, and engine No. 2, a 1953 Seagrave pumper. The Milton Civil Defense Support Services vehicle is taking up the rear.

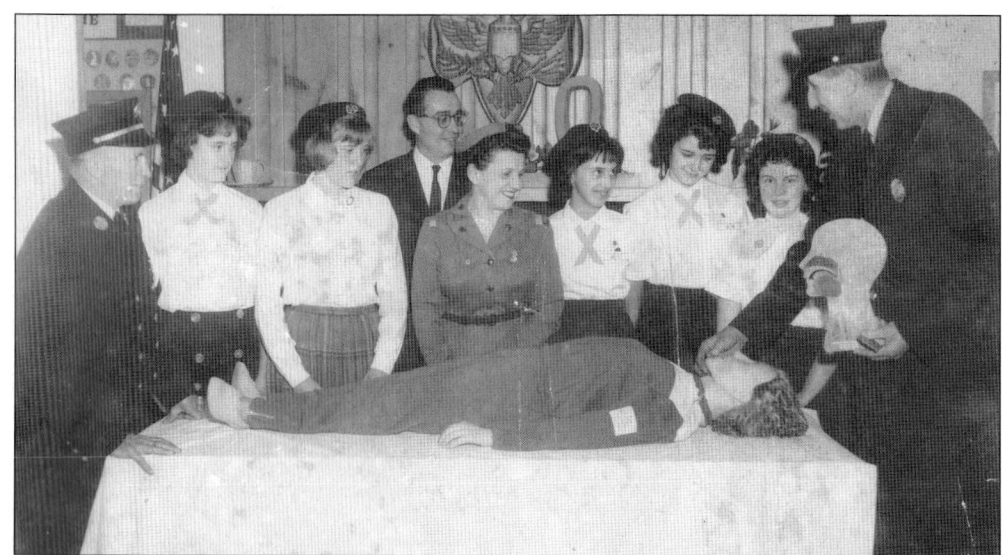

Girl Scout Troop 29 participated in lifesaving instructions, including mouth-to-mouth resuscitation, given by firefighter Robert Tucker under the direction of Fire Chief Lewis Lyons. On hand for the class in this photograph taken on January 20, 1963, are, from left to right, Fire Chief Lewis Lyons; Linda Geller; Mary Leonard; J. McCarthy of the New England Telephone Company; Mrs. Edward Cohen, troop leader; Sandy Cohen; Carol Chiavaroli; Rosemary Maloney; and firefighter Robert Tucker. "Annie," the practice dummy, is on the table. (Courtesy of Robert Tucker.)

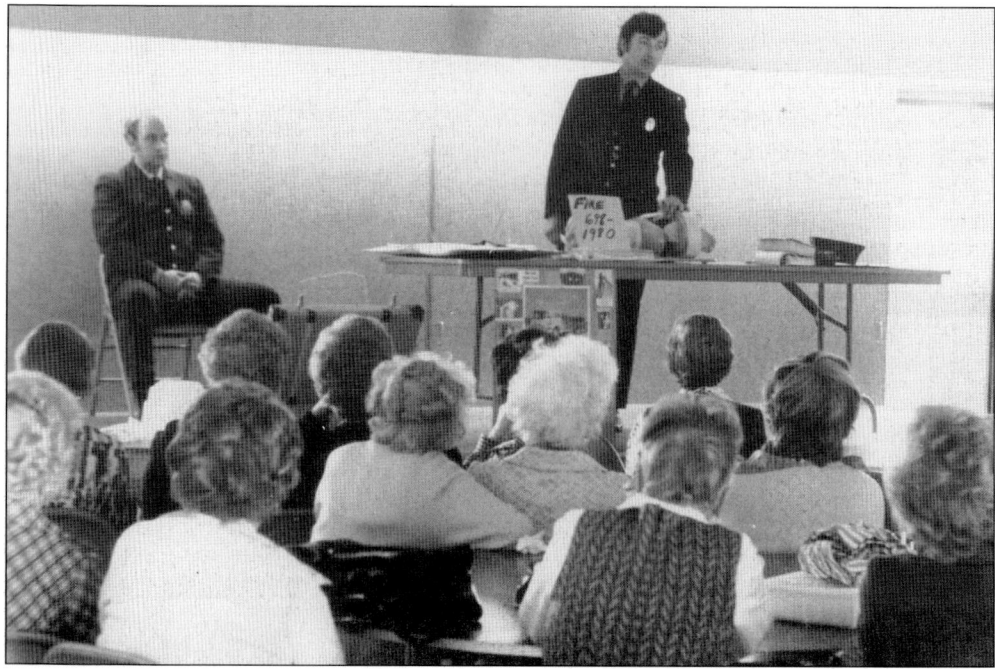

Firefighter David Forsyth gave a talk to a gathering of women at Cunningham Hall in 1971. The talk included fire safety tips, first aid instruction, and the proper methods to notify the fire department in times of emergency. Seated to the rear and assisting Forsyth in the program is firefighter Joseph Vogel.

Milton engine No. 4, a 1965 Mack truck, was stationed at the Atherton Street station. Sporting Mack's classic chromed bulldog on its hood, this fire truck was a bulldog itself. Its versatility allowed it to go almost anywhere along the horse trails in the Blue Hills, yet its 1,000-gallon-per-minute pumper with 500-gallon water tank made it a great street fire truck as well. This truck continued service in Milton for more than 20 years before being sold to a collector in the 1980s.

Schoolchildren have commandeered Milton combination No. 1, a 1948 Chevrolet brush firefighting truck at the Central Fire Station. This truck helped fight many fires in the Blue Hills and other wildland sections of Milton during its years of service. It served as Milton's brushfire firefighting truck for more than 20 years before it was replaced by squad No. 1 in the 1970s. In the 1980s, it was converted into a mosquito sprayer and was used by the Milton Department of Public Works in that capacity for several years. The photograph was taken about 1974.

Lined up in front of the Central Fire Station from left to right are ladder No. 1, squad No. 1, engine No. 1, and car No. 8, the deputy chief's car. The 1967 Maxim ladder truck boasted an 85-foot aerial ladder. Squad No. 1 was a 1970 International Harvester brushfire firefighting truck, and engine No. 1 was a 1953 Seagrave pumper. The car, a 1972 Ford Country Squire station wagon, was the deputy's car. Before 1964, the deputy fire chief in Milton rode on the front seat of engine No. 1 and was not available for inspections and other department work.

Engine No. 2, a 1974 Maxim pumper, was a 1,250-gallon-per-minute pumper and was specifically designed for the Milton Fire Department for its work on the Southeast Expressway. Notice the turret or deluge gun on the top of the cab. This was designed for fighting close-up car or truck fires on the expressway and could be controlled from the inside of the fire truck. Besides its pumping capabilities, the engine was equipped with a foam tank for flammable liquid fires and two 150-pound dry chemical tanks for fighting chemical and electrical fires.

Milton Post 114 of the American Legion honored Milton firefighters Robert McLeod and Robert McGee in a ceremony held at the post in 1974. McLeod and McGee are pictured here being congratulated by Massachusetts attorney general Robert Quinn of Milton and state representative M. Joseph Manning. The certificate reads, "For outstanding service to the community through carrying out the duties of a firefighter in a manner which reflects credit upon all fire department personnel and for dedication to the profession above and beyond the call of duty." From left to right are Manning, Quinn, McLeod, unidentified, and McGee.

In 1979, Lt. Robert Blake accepted this certificate of recognition on behalf of his fellow firefighters for their fund-raising efforts for the Muscular Dystrophy Foundation. Milton firefighters had placed numerous money canisters at area businesses in the fund-raising effort through which many citizens of Milton had contributed. Blake is standing in front of the department's latest acquisition: Milton engine No. 1, a 1978 Mack pumper, complete with the bulldog motif on the front windshield.

Milton firefighters demonstrate the newly arrived Jaws of Life and other rescue tools in this photograph of 1974. The new rescue tools were purchased through a raffle sponsored by the Milton Mothers Club, Curry College, and other community organizations. Pictured in front from left to right are Milton firefighters Robert Mason, Joseph Angeloni, and John Noris. Also in uniform in the photograph on the left side are Deputy Chief Eugene Lorden (second from left) and Fire Chief John Grant.

Demonstrating the Jaws of Life rescue tool on the automobile are firefighters Robert Mason, working the tool, and Joseph Angeloni, assisting Mason to Mason's right. Fire Chief John Grant (fifth from left) and Deputy Chief Eugene Lorden (third from left) look on with Milton selectmen. Other community leaders and citizens involved in the project to secure the rescue tools for the Milton Fire Department look on.

Milton's first EMT team gathers alongside ladder No. 1 in a photograph taken about 1976. Inspired by the hit television series *Emergency*, which portrayed the day-to-day lives of a California fire department rescue squad, fire departments from coast to coast redoubled their efforts to bring emergency medical services up to date in their organizations. Pictured in the photograph are, from left to right, firefighter/EMTs Joseph Vogel, Edward Jerdon, Robert Byron, and Robert McLeod.

A Milton firefighter is outfitted with a self contained breathing apparatus (SCBA) in this photograph taken about 1974. The apparatus was initially developed in the 1960s by the NASA for the U.S. space program and was quickly adopted by the fire service. In 1974, an air compressor and cascade system were installed at the Central Fire Station to refill the tanks at no cost to the department. Research has shown that the SCBA equipment has saved and prolonged the lives of countless firefighters nationwide.

Sixty years of progress in motorized fire apparatus design are reflected in the operator panel of the 1974 Maxim, Milton engine No. 2. From this pump panel the operator could deliver as much water, foam, and dry chemical extinguishing powder, through any one of the outlets, preconnected hose lines, or its cab-mounted turret gun, as any fire in Milton might require.

This photograph tells the story of progress in fire apparatus design in the 30 years difference between Milton engine No. 2 (1974) and old engine No. 4 (1944), then used as a spare engine. The clock tower and steeple of the First Parish Church rise in the background.

# Three

# THE CHIEFS OF THE MILTON FIRE DEPARTMENT

The traditional insignia for fire chief in the American fire service is five bugles. This badge is worn on the cap, collars, and buttons of the fire chief's uniform. The symbol pictured here was the creation of William J. Hicks, a Milton fireman from 1900 to 1941. Hicks, a sketch artist and painter, created many images during his career, depicting the ordinary, day-to-day life of a Milton fireman. Some of his other works are included later in this book. The following pages document the fire chiefs of the Milton Fire Department in the modern era, 1900 to the present.

Fire Chief George Choate was a member of the board of fire engineers when he was elected Milton fire chief in 1892. Choate began running with the Hydrant Engine in East Milton as a youngster and was associated with the fire department for more than 50 years at the time of his death. He was a founding member and first president of the Milton Firemen's Relief Association. (The association's name was changed to Milton Firefighting Relief Association in the 1990s to reflect the modern term for firemen.) His sudden death in 1913, while still serving as fire chief, stunned the fire department and the entire town. Together with his son Ernest Choate, he established the Milton Wire Department.

J. Harry Holmes was appointed chief of the fire department in 1914 to replace Chief George Choate. Holmes served the longest of any chief in the modern era, retiring on December 31, 1939. He led the department through the years of its greatest transition—from horse-drawn apparatus to motorization.

Fire Chief James Hanna was appointed on January 1, 1940. As a captain, Hanna had been made drill master of the department in 1920. He became the first deputy chief of the Milton Fire Department in 1926. Hanna led the department through the difficult years of World War II and was instrumental in establishing the Milton Civil Defense program and integrating it into the fire department structure.

Fire Chief Ashton McLeod replaced Hanna in 1948. Before retiring in 1951, McLeod set in motion the processes that finally led to the building of a new fire station in East Milton. As drill master in 1941, he helped initiate the Milton Civil Defense program. McLeod was the father of Milton firefighter Robert McLeod.

Fire Chief Frederick Whelan succeeded Chief Ashton McLeod in 1951. Whelan oversaw the construction of the new firehouse in East Milton, formerly Hose No. 2, now called Engine No. 2. Under his leadership, all department vehicles became equipped with two-way radios by 1960. Whelan commanded the fire department at several large fires, including the Hendrie's production plant and restaurant fire of 1952 and the Copley building fire in 1953. He retired in 1961.

Fire Chief Lewis Lyons served the Milton Fire Department for 33 years, 10 as fire chief. When Lyons joined the department in 1939, there were 25 professional firefighters, supplemented by a number of call men. Call men were slowly disbanded after World War II, and under Lyons's leadership, the department grew to more than 60 professional firefighters. Lyons was born in Quincy. His grandfather was Capt. Jeremiah Lyons of the Quincy Fire Department. Lyons was a 1925 graduate of Milton High School. He was a graduate of Northeastern University and held a degree in electrical engineering. He lived in Milton for 81 years and died in October 2001 at the age of 94.

Fire Chief John Grant succeeded Lewis Lyons as chief in 1972. Under his leadership, the department obtained the most modern and adequately equipped fire truck it has ever had—the 1974 Maxim pumper, engine No. 2. He also supervised the installation of the department's first air compressor and cascade system for the newly acquired SCBA. Grant was commended for his leadership of directing the department during the 1976 bicentennial celebrations in the town and for a comprehensive history of the fire department he wrote for the occasion. Under Grant's leadership in 1974, the Milton Fire Department became a member of Metro Fire District 13, a mutual aid program made up of the cities and towns of Greater Boston.

Fire Chief John O'Neill (left), an electrician by trade, began his fire department career as a member of the wire department. He was appointed fire chief in 1979 following the untimely death of Chief John Grant. Remembered as a good fire ground commander, O'Neill had the unenviable task of leading the department during the most difficult years of financial restraints, which resulted from the property tax initiative known as Proposition 21/2. Despite many cutbacks townwide, he managed to keep the department strength at more than 60 men during his tenure. In the photograph, O'Neill is congratulating Robert Blake as the new fire chief in 1984. If Blake appears a little flustered it is because he borrowed the slimmer O'Neill's dress coat for the photo opportunity.

Fire Chief Robert Blake succeeded Chief John O'Neill following the latter's retirement in 1984. Blake was the son of well-known Milton police officer Robert Blake of East Milton. He served as the Milton firefighters' union president for many years. He later rose to become a district vice president of the Professional Firefighters of Massachusetts. Known for his leadership abilities, Blake was the logical choice of the selectmen when the chief's spot opened in 1984. He is the only member in living memory to be promoted to chief of the fire department from the rank of lieutenant.

Fire Chief Jean Callahan succeeded Chief Robert Blake in 1989. Callahan, a 1951 graduate of Milton High School, began his career with the Milton Fire Department in 1961. He was promoted to lieutenant on July 31, 1978, and deputy chief in March 1982. As deputy chief, he was the incident commander at the Ladd estate fire of January 1, 1984, and the Smith Road fire of December 1984. Callahan grew up on Clapp Street near the Central Fire Station and spent a lot of time there as a child. He has fond memories of interacting with the old-time firemen of that day and of playing horseshoes with them in the backyard of the firehouse. Callahan is standing in front of ladder No. 1, the 110-foot aerial ladder truck, in this 1989 photograph.

Before joining the fire department in 1962, John Hanafin spent seven years with the Milton Police Department. He was appointed Milton fire chief in 1990 and retired from that position in 1993, after almost 40 years of service between the police and fire departments. Hanafin was a member of the Milton Yacht Club and was an avid golfer. He was a 1948 graduate of Milton High School and studied fire science at Massasoit Community College to keep up with the latest in firefighting technology and methods. Hanafin was an army veteran of the Korean War.

Donald Affanato was appointed Milton fire chief in 1993, succeeding Fire Chief John Hanafin. Prior to his tenure as chief, Affanato served Milton firefighters at the union level for many years, including president from 1980 until 1986. Under his guidance, the fire department acquired two of its most up-to-date pieces of fire apparatus—engine No. 2, a 1994, 1,250-gallon-per-minute pumper manufactured by the Emergency One Corporation of Ocala, Florida, and engine No. 4, a 1998 model of the same make. He is pictured here in 1998 with state representative Walter Timilty, who is congratulating him on his latest acquisition.

Fire Chief Malcolm Larson (left) succeeded Chief Donald Affanato in 1998 and is the current leader of the Milton Fire Department. Larson began his public safety career in 1969 as a search and rescue team member in the United States Coast Guard. He joined the fire department in 1977 and was promoted to chief in 1998. After serving the Coast Guard for four years, he claimed, "Choosing a career as a Milton firefighter was a perfect fit and something I have never regretted." In an interview in 2005, Larson stated he was an advocate of basic risk management: "Smoke detectors, seatbelts, and a modern fire department are essential to every family's safety, but all too often are not a priority."

## Four

# LIFE OF A MILTON FIREMAN

William J. Hicks joined the Milton Fire Department in 1899, serving as a call man until he was appointed a permanent fireman in 1916. A carriage maker by trade, he worked for his father for many years before he took up full-time firefighting. In his spare time Hicks, a skilled cartoonist, captured many of the day-to-day activities he witnessed as a member of the fire department. Photographs of Milton Fire Department activities in this period (1900–1940) are rare, but Hicks used his artistic skills to depict many of the scenes that the camera may have missed. The following examples of his artwork were donated by his daughter and are maintained in the Milton Firefighters Memorial Archives. This self-portrait was done by Hicks in 1930.

William J. Hicks learned the skills of carriage making from his father and was adept at painting or drawing the fire apparatus and the horses that pulled them. In this painting, Milton steamer engine No. 1 races to a fire with an eager driver and fireman aboard. The painting is on display in the collection of the Milton Firefighters Memorial Archives.

On the afternoon of February 23, 1920, fire broke out at Bent's Cracker Factory on Pleasant Street near Randolph Avenue. No employees were inside the building due to the George Washington's birthday holiday. On a cold winter day following a heavy snowfall, the fire department responded to the scene of fire in its horse-drawn sleds. On the right, a police officer prevents a streetcar from crossing the hose-covered tracks. The fire was confined to the upper floors where it originated. Total fire loss, including the loss of 450 to 500 barrels of flour, was estimated at $12,000. The bakery was able to reopen the following week.

Milton engine No. 4 shines its spotlight upon the scene of a chimney fire in the Brush Hill section of town as firemen attempt to raise a hose line to the roof. Black ash and burning embers dominate the nighttime sky. The weather observatory on top of Great Blue Hill is seen in the distance.

In this scene of an automobile accident and fire, William J. Hicks identifies the firemen on scene, including, from left to right, Edward Frost, John Tolman, James Hanna, and William Hicks carrying a lantern. Typically Hicks captured the comical yet stark reality of the situation for the stranded men. The trains are not running at 2:00 a.m., and Cambridge will be about a 15-mile walk from Milton.

Automobile fires were occurring more frequently as the machine had become the most desired form of transportation by December 6, 1917, when Hicks captured this scene at the intersection of Central Avenue and Reedsdale Road. Known locally as Kerrigan's Corner, the prominent business in this vicinity was John Kerrigan's gas station, where gas was listed at 25¢ per gallon. John Tolman is driving engine No. 1 with Captain Hanna in the passenger seat. In this sketch, Hicks also recorded the temperature that night—10 below zero. Milton police officer Timothy McDermott looks on.

54

In an undated drawing, Hicks and fellow firemen Frank Mullen, Charles Splaine, and William Creedon save the life of Tudor Leland on a pond in the Brush Hill section, as the boy's father watched in relief. The child, son of a famous millionaire of Milton, had strode out onto the ice to retrieve his dog.

With his pens, pencils, and paints, Hicks captured that period when the fire department was shifting from horse-drawn fire apparatus to the motor-driven vehicle. This 1919 Oldsmobile truck was converted into a chemical fire engine by Milton firemen when they affixed an old horse-drawn chemical wagon to the rear chases. Hicks, a trained carriage maker, no doubt had a hand in the project and was proud enough to produce this image. The basket on top was used to store the firemen's gear. This truck was in service until the 1930s. The Oldsmobile was fully restored by a local resident and is now part of the Milton Firefighters Memorial Archives.

During a practice drill on May 19, 1921, six Milton firemen raised a 50-foot ground ladder against the bell tower of the Central Fire Station, with one man climbing to the top, in an amazing time of 38 seconds. The event was timed by fireman Ernest Soulis and Lt. Henry Briarly and witnessed by William J. Hicks in this seven-frame sketch.

A climbing William J. Hicks performs one of the most routine, as well as despised, duties of a fireman—the rescue of a cat in a tree—as his fellow firemen call for him to drop the cat in a blanket below. Hicks does not seem to want to be there any more than the cat wishes to be rescued. The sketch is dated November 1921.

57

In this image, William J. Hicks portrays a fire that occurred on the night of December 7, 1939, when a barn owned by Michael Gibbons caught fire at the end of Grove Street. The first alarm was transmitted by the fire department at 8:04 p.m. The two-alarm fire left embers that smoldered through the night, and the all-out signal was not sounded until 6:40 a.m. The barn, a truck, and 15 tons of hay were all destroyed. Damage was estimated at $3,500.

Two firemen direct a stream from the nozzle of a two-and-a-half-inch hose line into a doorway as smoke billows out from within the building. Hicks has depicted the fireman in the foreground wearing his helmet reversed. Using the wide brim portion of the helmet for added protection, the reversed helmet technique deflects the radiant heat of the fire away from the firemen's face.

# *Five*
# MILTON FIREFIGHTING

The Milton steamer races to a fire in Milton Village in this photograph taken about 1900. In winter, an additional team of horses was required to pull the heavy apparatus through the snow-covered streets. The smoke issuing from the steamer stack indicates that the boiler is stoked and the engine will be ready to pump water upon arrival.

# $400 REWARD!

Four hundred dollars reward will be paid by the Selectmen of Milton, for the detection and conviction of the person or persons who maliciously set fire to the barn of Mr. D. O. CLARK, on Sunday Evening last.

## ALSO, $200

will be paid by Mr. Clark, in addition to the above amount.

R. M. TODD,
S. A. BURT,
JOHN TOLMAN,
Selectmen of Milton.

Milton, Aug. 14th, 1872.

ROCKWELL & CHURCHILL, PRINTERS, 122 WASHINGTON ST., BOSTON.

Fires, such as the one described in this 1872 reward poster, were making town leaders realize that their fire department had not kept up with the growth of the town. For many years, the volunteer companies of Milton Village and East Milton were the sole fire protection forces of all Milton. Posters such as this may have helped to catch the person responsible, but the fire problem continued in Milton. Finally, in 1881, a new firehouse was erected in Milton Center and a chemical engine installed there for the better protection of citizens in that part of town. Soon after, in 1887, an even larger station was built next to the chemical house for a new steam engine and hose wagon. This became the Central Fire Station and headquarters of the Milton Fire Department and remains so to this day.

The bygone era of the steam fire engine is portrayed in this photograph. The scene appears to be Milton Center looking toward Clapp Street with the most recognizable structure seen rising to the right—the clock tower and steeple of the First Parish Church off Canton Avenue. Two steam fire engines are connected into a hydrant and are pumping water toward an unknown fire scene. Milton Center was completely serviced with fire hydrants by 1900. The buildings in the foreground are unrecognizable today.

This photograph is of the same period along a Milton road no longer recognizable. The town owned only one steam engine, so this may have been a relay pumping operation between Milton and Dorchester fire companies. In this photograph, a fire hydrant has been placed into operation to feed the steamer on the left. Milton was completely serviced by fire hydrants in populated sections by the 1920s, but unpopulated areas required long lays of hose boosted by pressure from the pumpers. These two photographs of steamers in action are rare in the collection of the Milton Firefighters Memorial Archives.

The fire scene depicted in this photograph took place on upper Canton Avenue, in the Brush Hill section of town. It shows the remnants of a barn after a fire, with its damaged contents, mostly hay, laid outside the building. The tower to the right is a fire bell tower constructed by the fire department in that section of town to alert the call firemen at times of fire. The photograph was taken by Ernest Choate about 1895. Fires such as these were occurring more frequently in the western side of Milton and finally, after a child was killed by fire in 1900, a permanent fire station was built on Atherton Street in 1901. Similar fire alarm bell towers were constructed on Oak Street and later on Blue Hill Avenue, opposite Concord Avenue. (Courtesy of the Milton Historical Society.)

These Milton firemen appear to be chaining the chimney on the roof of the Sutermeister home on upper Canton Avenue about 1900. The firemen have laddered the roof following a chimney fire, a very common occurrence in homes of that period. The fire department ladder truck pung, or sled, is idle on the left side of the photograph. Fire helmets and other gear are stored in a basket above the ladders for the firemen's use if needed. Emmanuel Sutermeister was a call fireman in Milton in the 1890s. He was the father of famed Milton photographer Margaret Sutermeister, who captured this scene with her camera. (Courtesy of the Milton Historical Society.)

Samuel Gannett's Grain, Flour, Hay, and Straw market had long been a prominent business in Milton Village. Located on Adams Street, just before the Milton bridge, it occupied land now owned by the Extra Space Storage facility. Besides the grain business, the building was also occupied by a dressmaking shop and a fruit store. The center building was once John Lillie's home and shop, also pictured on page 2. In the photograph below, Milton police officer Charles Page, who discovered the blaze and sent the first alarm, takes position for crowd control on Adams Street as firemen work to extinguish a blaze that broke out at Gannet's on October 15, 1906. The rear of Milton's chemical fire engine is seen on the right. At this point, smoke has completely obscured the grain elevator.

The image above shows hoses laid, ladders thrown, windows broken open, and firemen working on the roof of the building. Firemen continue their assault upon the fire at Gannett's, which also completely destroyed the dressmaking shop. The owner, Miss J. A. Morrissey, with an employee and several customers, escaped uninjured soon after the fire was discovered. A steam fire engine on the right is feeding the large attack lines. Fire hydrants had been installed throughout Milton Village as early as 1881. In the photograph below, the crowd has thickened as firemen make progress on the fire, which appears to be contained. Assisting at the scene were Boston fire companies Engine No. 16 and Ladder No. 6 from Dorchester, Engine No. 19 of Mattapan, and Engine No. 20 of Neponset. The fire, which broke out shortly after noon, was described in the local newspaper as "one of the most threatening fires that Milton has known in a long series of years." After an investigation, Chief George Choate determined that the fire was started by sparks from a nearby locomotive engine.

In the early morning hours of February 14, 1934, fire broke out at 184 Pleasant Street, the home of the Shoolman family. Milton fire lieutenant George Hersey was manning a charged hose line on an icy ladder when he suddenly fell back, striking his head on the ground. He was taken immediately to the Milton hospital by police ambulance and was pronounced dead on arrival. Hersey, who was 59 years old, left a wife, a daughter, and one grandchild. Hersey was remembered by Chief J. Harry Holmes as "an A-1 man, always easy to find when you needed him; never shirking his duties." The 18th-century house was completely destroyed. Firefighters were hampered by subzero temperatures, and the house, although burning fiercely from within, was described as a "shining mass of ice on the outside." (Courtesy of Boston Public Library.)

Formerly named the Eliot Creamery, Hendrie's Ice Cream Manufacturing Company was established in Milton about 1930. A favorite of area residents as well as business people, Hendrie's had a popular dairy bar and luncheonette with tables for seating outside in good weather. Hendrie's occupied the site where the National Biscuit Company operated for many years, at the intersection of Eliot Street and Central Avenue. Hendrie's advertised "the most delicious ice cream made from the finest local dairy products expertly blended with fresh fruits and true flavors." (Courtesy of the Milton Historical Society.)

On Saturday morning, July 26, 1952, at 5:30, two workers discovered a smoky fire as they arrived for work and immediately notified the fire department. The first alarm was sounded at 5:31 a.m. A second alarm and then a general alarm were ordered by acting deputy chief William Gustafson shortly after arriving on the scene. Chief Frederick Whelan assumed command on arrival. In this photograph, firefighters have placed two aerial ladders to the roof of the building on the Central Avenue side. (Courtesy of the Milton Historical Society.)

Firefighters placed several attack lines into position while operating from the aerial ladders. The heavy smoke shows that the fire has made headway and is already involving a good portion of the building and has vented itself. Heavy fumes from the ammonia tanks in the refrigeration system handicapped the efforts of the firemen until the tanks could be turned off. The blaze was described as Milton's worst fire in the eyes of its oldest inhabitant and in the estimation of most of the citizenry. Quincy Ladder No. 2 took up position on Eliot Street and placed an attack line into operation into the upper floors on arrival. At the height of the blaze, a section of the roof of the main building collapsed. (Courtesy of the Milton Historical Society.)

Two firefighters operated from the roof of the garage off Eliot Street near where the fire was first discovered by drivers for the company early that morning. As the fire progressed, a hot air explosion, or back draft, occurred in the basement of the three-story building, blowing out windows and sending a huge surge of smoke into the morning sky. Dense, black smoke covered the entire area for several hours, shutting out the sun over much of Milton and Dorchester Lower Mills. In all, eight firemen were injured during the fire. (Courtesy of the Milton Historical Society.)

Boston Engine No. 16 of Dorchester Village deployed its deluge gun from the Central Avenue trolley tracks along the river behind the ice-cream plant. Hose lines were laid across the MTA (Massachusetts Transit Authority) rapid transit tracks, cutting off transportation service for more than four hours. A total of 10 fire companies fought the blaze, including five from Milton, two from Quincy, and three from Boston. The mutual aid companies were Boston Engine No. 16, Engine No. 19, and Ladder No. 6 and Quincy Engine 4 and Ladder No. 2. The entire plant, which rose three stories in some sections, was gutted inside. However, the fire was prevented from reaching the business offices and dairy bar, which suffered smoke damage. (Courtesy of the Milton Historical Society.)

A woman and three children watched the firemen battle the blaze from Central Avenue. The blaze was described by local residents as a blast furnace. As the flames leapt from window to window, the fire consumed the many cardboard boxes used for storing the ice cream. The Milton chapter of the Red Cross was on hand from 8:00 a.m. Herbert Stranger operated the Metropolitan wagon used by Milton in times of disaster to provide first aid and refreshments to the firemen. Two firemen overcome by smoke were transported to Milton Hospital by the Red Cross. Much of the ice cream was preserved by employees of the company who formed bucket brigades to unload the mostly two-and-half-gallon containers from a rear storage compartment. Firemen and children were treated to as much ice cream as they wanted. Two children head home with their reward as they pass the white Quincy ladder No. 2. (Courtesy of the Milton Historical Society.)

This postcard sketch shows Milton Village as it looked in the early 1950s. The view is looking down Adams Street toward the river with the Walter Baker Chocolate Company factory buildings in the distance. On the left side, just beyond the Jenny gas station sign, is the building at 45–53 Adams Street known as the Copley building, which housed numerous businesses in 1953. In earlier times, the century-old building housed a horse stable, a carriage making shop, and a leather tannery and was still affectionately called Crossman's Stables by many local people. In 1953, the building was occupied by Hezlitt's Card and Stationery Shop, a small lending library, a shoe repair shop, and Henry Palmer Realtor, as well as other businesses. (Courtesy of the Milton Historical Society.)

On the morning of November 22, 1953, a passerby noticed smoke coming from the upper stories of the Copley building and immediately turned in a fire alarm. As firemen arrived on the scene, huge clouds of smoke billowed upward as they laid water supply hose lines and began to encircle the building with attack lines. In this photograph shot early in the firefighting effort, Milton firefighters operated from a ladder truck, placing a two-and-a-half-inch attack line into position. A deck gun is operating from behind the ladder truck. (Courtesy of the Milton Historical Society.)

71

Following a general alarm ordered by Fire Chief Frederick Whelan, additional firefighting units responded from Quincy and Boston. In these two photographs, firefighters have surrounded the building and are concentrating on two main exposure problems—the Jenny gasoline station on the left side of the Copley building and the Norfolk County Trust bank building on the right. One engine and one ladder responded from Quincy, and before it was under control, five engines, three ladder trucks, and two rescue companies responded from Boston. (Courtesy of the Milton Historical Society.)

Firefighters continued to pour water on the inferno for more than two hours while smoke billowed into the darkened morning sky. At times it was estimated that flames raged more than 200 feet skyward. A crowd gathered along the Adams Street side of the structure to witness the destruction. Off-duty police officers were called in for crowd control. A newspaper estimated the crowd to be nearly 1,000 people, many on their way to or coming from Sunday church services. It was three hours before firemen could take a break and enjoy the coffee and doughnuts provided them by the Salvation Army and the Milton chapter of the Red Cross. (Courtesy of the Milton Historical Society.)

While checking for fire extension on the roof of the building, the roof partially collapsed and Boston firefighter Arthur Morton fell more than 50 feet into the basement. In a heroic effort, three of his comrades slid down lengths of hose into the basement to reach him and bring him to safety. These two photographs capture the rescue effort while it was still in progress. After being rescued, Morton was immediately transported to the Boston City Hospital, suffering from spinal injuries. Additionally two Milton firefighters were injured in the same collapse when a wall fell, momentarily entrapping them. Joseph Duffy and Timothy Foley were taken to Milton Hospital with less severe injuries, treated, and released. (Courtesy of the Milton Historical Society.)

The blaze was brought under control in a little more than three hours. Firefighters were detailed to stand guard throughout the night and remained until the following Tuesday, extinguishing flare-ups on several occasions. The photograph above shows Milton firemen, including Robert Tucker, directing their stream onto the smoldering wreckage from the roof of the Norfolk County Trust building (now Bank of America), which was saved by the water curtains deployed during the blaze. Fire Chief Frederick Whelan ordered the building razed, and on Tuesday, the wrecking crew of the L. L. Duane Company moved into position to complete the job. Whelan estimated the total loss on the structure at $75,000. Before the fire was completely extinguished, area residents and businessmen began the process of establishing a fund to help those most affected by the fire, including the injured firemen. (Above, courtesy of Robert Tucker; below, courtesy of the Milton Historical Society.)

# DISASTER
## could strike YOU too!

All fires are unexpected - Nobody is safe from the destruction of property and the financial losses from damage by fire.

# GIVE TO THE MILTON VILLAGE FIRE FUND

Organized by friends and public-spirited citizens to help out those most seriously affected by Sunday's fire.

Contributions may be sent to:

RICHARD SCHMIDT, treasurer
Milton Village Fire Fund
c/o Milton Savings Bank
62 Adams St., Milton Village

75

The Caroline Saltonstall Gymnasium at Milton Academy was located on Gun Hill Street. It originally served as the boys' school gymnasium but was moved across campus when a new brick gymnasium was constructed off Centre Street by Robert Saltonstall in 1922. The old gymnasium was then converted for use of the girls' school. (Courtesy of the Milton Historical Society.)

On Saturday evening, April 7, 1956, a blaze was discovered at the gymnasium by a night watchman at 12:30. A boys' school instructor simultaneously heard a loud explosion coming from the building, and he immediately notified the fire department by telephone. On arrival, the firemen found the upper floors of the two-story building totally engulfed in flames. (Courtesy of Robert Tucker.)

Firefighters from Boston and Quincy joined the Milton department in battling the blaze. Spectators, attracted by the towering flames that were visible for miles, jammed into the area, and extra police had to be called for crowd control. Water curtains were deployed to protect a nearby teacher's home and another building belonging to the girls' school. The loss of the gymnasium, which was destroyed, was estimated at $150,000 to $200,000 by Fire Chief Frederick Whelan. (Above, courtesy of Robert Tucker; below, courtesy of the Milton Historical Society.)

# 68TH ANNUAL BALL 1963

Cover: Curry College Fire, General Alarm, No Injuries. UPI Telephoto.

**MILTON FIREMEN'S RELIEF ASSOCIATION**

The 1963 Milton Firemen's Relief Association annual ball booklet recalled the most spectacular blaze of that year at Curry College in an old dormitory building, Boston Hall. The fire, which broke out shortly before 5:00 p.m. on January 7, 1963, quickly turned into a general alarm that brought assistance from the Boston, Quincy, Canton, and Needham Fire Departments. Milton firemen, under the direction of Chief Lewis Lyons, were on scene for more than 24 hours. Students were praised for their orderly evacuation and alerting one another to the danger. The fire was thought to be caused by a malfunctioning oil burner. The building was totally destroyed, and fire officials estimated the loss to be more than $250,000.

The Mattapan Paper Mill was established on the Milton side of the Neponset River on the upper falls of Mattapan about 1800. James Boise established a mill here as early as 1760. Edmund Tileston and Mark Hollingsworth learned the paper-making trade in Milton Village, and in the early 19th century, they partnered in establishing a paper mill here. By 1965, the old paper mill site was owned by the Diamond National Company. This business, located along the river off Blue Hills Parkway and Curtis Road, was now a lumberyard and sold power tools and hardware to area craftsmen. (Courtesy of the Milton Historical Society.)

On June 30, 1965, a general alarm fire caused damage estimated at more than $50,000 at the Diamond National Company lumberyard located at 10 Blue Hills Parkway. The blaze destroyed a large warehouse loaded with costly power and hand tools. Large stocks of shingles, prefinished plywood, and roofing supplies were also destroyed. The blaze spread to the office and retail store before it was finally checked by the combined efforts of the Milton and Boston Fire Departments. The fire sent large columns of dense, black smoke into the early evening sky, visible for miles around. (Courtesy of the Milton Historical Society.)

The blaze was discovered by a neighbor on Curtis Road who notified the yard manager, Arthur McClellan. McClellan, who had been working in the yard, immediately called the fire department upon realizing the place was on fire. Cause of the blaze, which started in the lower portion of the shingle shed, was not immediately determined. (Courtesy of Joseph Angeloni Jr.)

Unquity House for senior citizens of Milton, located at 30 Curtis Road, now occupies the site where the paper mill of Edmund Tileston and Mark Hollingsworth and Diamond National Company lumberyard operated for many years. The beautiful condominium complex managed by Milton Residences for the Elderly was built about 1972. (Courtesy of James Quinn.)

Milton police officers place Milton firefighter Robert Ellis into the police ambulance after he was overcome at a house fire at 229 Eliot Street on the morning of August 3, 1965. At the height of the blaze, firefighters rescued one woman and four children over aerial ladders. The photograph reminds one of the hazards of the job and the selfless spirit of firefighters as they risk their lives to save others in danger. Following treatment at Milton Hospital for smoke inhalation, firefighter Ellis was released and returned to work shortly after this incident. The development of SCBA in the 1970s has greatly reduced these types of injuries to firefighters.

In early May 1974, Milton firefighters were commended by their fire chief and others for their efforts to save and then recover the body of a young drowning victim from the Neponset River in Milton. During the ordeal, Milton firefighters spent their off-duty hours, some using their own personal boats, in an effort to widen the search. These photographs show Milton firefighters working in conjunction with Metropolitan State Police Department divers at the dam on Adams Street in Milton Village. The boy's body was recovered days later well downstream from this location. With miles of shoreline along the Neponset River as well as the many streams and ponds of water in Milton, firefighters are often called to perform this type of rescue work.

Always ready to serve a good meal to hungry firefighters, Milton firefighter Joseph Angeloni was especially known for his spaghetti and meatball dinners served at the Central Fire Station. Firefighting had evolved into a full-time profession in Milton, requiring round-the-clock shifts at the firehouse. A fully equipped kitchen and a good cook are a must for any full-time fire department. The Central Fire Station, the largest firehouse in Milton, was the quarters of the men of Ladder No. 1, Engine No. 1, Squad No. 1, and the deputy chief. At any time, there could be as many as 16 men on duty to feed. In the photograph below, the dinner table is set, awaiting a famished crew.

The Thacher School was built in 1890 to replace the Centre School, which ceased operations that year. It stood on land formerly owned by the Unitarian Church and was located on what is now Walnut Street near Clapp Street. In 1898, the school suffered a fire on the Fourth of July but was spared from destruction. For more than 80 years, it served as a schoolhouse, town office building, American Legion hall, and youth counseling center before being torn down in the 1980s.

In the late afternoon of Saturday, January 18, 1975, a fire broke out in the upper floors of the Thacher Building and was discovered by youths assembled there who immediately notified the fire department. Upon arrival, with smoke showing, Milton firefighters quickly ascended the aerial ladder of ladder No. 1 to begin venting operations.

A firefighter has gained a foothold and begins venting the roof of the building as two others approach from ladder No. 1 to assist him. This photograph, taken by Milton photographer Don Finn, received a blue ribbon first-place prize in the action category in a photography contest held during the annual meeting of the Massachusetts Selectmen's Association in September 1975.

Smoke rises into the early evening sky as firefighters continue roof operations and interior crews check for fire extension in the upper rooms and attic of the Thacher Building. While Milton firemen fought the two-alarm blaze, the town was covered through mutual aid by the Boston Fire Department. Because of the quick response and efficient work of the fire department, the fire was contained to the upper floors and damage, kept to a minimum, was estimated at $4,000.

Firefighters remove debris as part of the salvage and overhaul process. In 1975, the building was being used as a town youth drop-in and counseling center. The building was spared and continued to serve as a youth center for a number of years before being torn down in the early 1980s. The site is now the location of the Milton Senior Center off Walnut Street.

Dusk has settled into night as Fire Chief John Grant (left) and Deputy Chief Timothy Foley discuss the ongoing strategy of the firefighting crews at the Thacher Building fire of 1975.

The Bartlett Building was located at the intersection of Blue Hills Parkway and Blue Hill Avenue near Mattapan Square and was the location of numerous Milton businesses, including a dentist office, a hairdresser, a pharmacy, and an insurance company. On Tuesday, September 23, 1976, fire broke out at the building located at 67–71 Blue Hills Parkway. Milton ladder No. 1 extended its 85-foot aerial to fully reach the roof of the burning structure, also known as the Parkway Building by local residents. In the photograph at right, Milton firefighter John Martinelli positions ladder No. 1 to the roof of the burning structure on the Blue Hills Parkway side.

87

A Milton firefighter is all business as he attempts to "open up" the roof of the Parkway Building, nicknamed the "flatiron" because of its sharply pitched roof section resembling an old-style hand iron. In firefighting jargon, "open up" describes the process of venting the roof to remove the heat, smoke, and dangerous gases, including carbon monoxide, from the upper portions of the building, enabling firefighters to reach the seat of the fire with their hose lines.

Firefighters direct the aerial ladder of ladder No. 2 as their comrade continues the venting operation on the roof. Milton Engine No. 1, Engine No. 2, and Ladder No. 1 fought the blaze from the Blue Hills Parkway side of the structure, while Engine No. 4 and Ladder No. 2, assisted by Boston Engine No. 16, fought the fire from the Blue Hill Avenue side.

A Milton firefighter continues to apply his ax to the roof of the building in an effort to improve the ventilation process. In addition to all Milton fire companies working, the department was assisted on scene by apparatus from Quincy, Boston, and Dedham. Milton had recently joined the newly created Metro Fire District 13 network, which directed the mutual aid efforts for this fire via a specially designated radio frequency. The fire did over $100,000 in damage to the structure and displaced more than 10 businesses. The building was torn down later that year and the site grassed over, and it remains so to this day.

A Milton firefighter takes a well-deserved break on the side step of engine No. 1. Firefighting is a physically demanding occupation, and this factor is often compounded by the effects of breathing the poisonous by-products of combustion such as carbon monoxide. This photograph is symbolic of the hazards of the job and the physical price firefighters often pay as they work to protect the lives and property of their neighbors.

89

The Walter Baker Chocolate Company formerly occupied this building located at 2 Adams Street in Milton Village. For many years, the building was a shipping and receiving warehouse serviced by trains and trucks delivering the required cocoa beans and departing with the world-famous Baker's Chocolate product before the chocolate company moved out of town in the 1960s. Humbolt Movers and Storage Company occupied the building on February 8, 1975, when Milton firefighters responded to a reported fire in the rear of the facility. On arrival, firefighters found several storage compartments well involved in fire from an unknown source and quickly gained entry to the loading platform area to extinguish the blaze.

The compartment bins of the storage facility could hold anything from furniture to office records and presented the firefighters with the challenge of reaching the unusual, concealed spaces on the loading platform to thoroughly extinguish the fire. In this photograph, a firefighter attempts to get the proper angle to penetrate the smoldering wood framed compartments. Through their quick actions, firefighters were able to contain the fire to the storage bins and platform roof.

The image in this photograph is reminiscent of a long past era when freight trains paid a daily visit to Milton Village to service the factories and warehouses of Milton and Dorchester Lower Mills. Here a boxcar smolders from an unknown source as a Milton firefighter attempts to gain a foothold between a fence and the train to extinguish this fire located along the river near the Central Avenue bridge.

Milton Squad No. 1 is working the scene of a brushfire along the paths of the Blue Hills Reservation. The truck was a 1970 International Harvester purchased by Chief Lewis Lyons for brushfire firefighting operations such as this. Besides a 500-gallon tank of water, the truck was equipped with a four-wheel drive option and had a winch machine box built into the front bumper.

A portable pump was set on the back step of Squad No. 1, which allowed the apparatus to be operated while still in motion, an operation known as "pump and roll." This pump allowed firefighters to attack the fire simultaneously as the truck traveled along the wooded paths. The department's pet dalmatian Goliath is seen on his bed behind the squad in this photograph taken about 1975. The dog was a favorite among Milton firemen as well as schoolchildren on firehouse visits.

Milton engine No. 1 races off to another fire in this 1976 photograph. Engine No. 1 was a 1953 Seagrave pumper equipped with a 500-gallon water tank. A 300-foot, one-inch booster line on a single reel was handy for small fires, car accidents, and other small cleanup jobs. Besides the booster line, the truck could pump up to 1,000 gallons of water per minute through numerous and various sized preconnected hose lines. The building in the background is the newly built town office building constructed in the early 1970s to replace a 19th-century structure. The photograph shows how the firemen rode on the back step of the fire engine, a practice that is no longer allowed for safety considerations.

Goliath, the department mascot, stayed behind for a nap on the seat of ladder No. 1, not needed on this run, while a firefighter's gear is ready for the next call.

Truck and automobile fires always present different sets of circumstances and challenges to firefighters, depending on several factors including size, location of fire, and time of day. In the photograph above, firefighters will need to release the engine hood of the medium-size truck before getting to the seat of fire in the engine compartment. In the 1960s through the 1980s, many automobiles were torched, often at night, by owners seeking to take advantage of lenient and generous insurance policies. These fires often occurred in out-of-the-way, isolated stretches of road as depicted in the photograph at left. Despite stricter insurance laws in Massachusetts, motor vehicle fires continue to be a problem in America. For example, according to the National Fire Protection Association, in 2005 U.S. fire departments responded to an average of one highway vehicle fire every two minutes.

Milton firefighters and police officers rescued a trapped motorist whose convertible automobile rolled over off Hillside Street in the Blue Hills Reservation on August 8, 1974. Two other victims, a mother and her three-year-old daughter, were able to climb out from beneath the wreck, but it took the combined efforts of the firefighters and police officers to lift the car and extricate the trapped father. The man was administered first aid by Milton firefighter/EMT Robert Byron and then transported to Milton Hospital via police ambulance with severe injuries.

Milton engine No. 4, a 1965 Mack pumper, maneuvers its way along a wooded path at a brushfire in the Blue Hills Reservation in 1976. The truck was a versatile engine that could reach most areas of the state reservation when other engines could not. Its 500-gallon water tank with a 1,000-gallon-per-minute pump made it a great street firefighting truck as well. Many sections of Milton qualify as urban/wildland interface zones, defined as areas where residential construction encroaches closely upon potential wildland fire areas. In the photograph at left, firefighter Joseph Vogel douses a stubborn brushfire that took place in the Blue Hills Reservation in the spring of 1976. With thousands of acres of conservation and recreational woodlands in Milton, the fire department is constantly challenged to update its equipment and techniques to combat these difficult fires, which often threaten nearby homes, barns, and places of business.

In the aftermath of a snowstorm in January 1978, Milton firefighters fought a blaze in a house located on Blue Hill Avenue near Curry College. Four alarms were struck for this fire by Deputy Chief Eugene Lorden, shown here ordering ventilation of the roof as Milton ladder No. 1 positions its aerial ladder. Despite the destruction evident in this dramatic photograph, there were no injuries and the house still stands. Lorden was a founding member and the first president of the Milton Firefighters Union Local 1116 of the International Association of Firefighters when it organized in December 1952.

On December 26, 1984, at about 2:00 p.m., fire broke out in this Tudor-style three-story mansion located at 80 Smith Road in Milton. Three people were home at the time of the blaze and managed to escape unharmed. Upon arrival, Milton firefighters found the structure well involved in the upper portions and after making an attempt at an interior attack were forced to fight the fire from the outside of the house. As Milton firefighters placed a deluge gun into operation, Deputy Chief Jean Callahan (in white helmet) confers about tactics with Fire Chief John O'Neill in the photograph below. (Courtesy of James Quinn.)

As the fire progressed, exterior operations ensued. To get a better hold of the fire, firefighters placed a ladder pipe into a front window, knocking down the blaze in that section. Milton was assisted at the scene by an engine and ladder truck from the Boston Fire Department while Quincy covered the town. The fire completely destroyed the home, which was torn down in the following days. The home was occupied by the Carroll family, including John and Penny Carroll and 10 of their 18 children. In the aftermath of the fire, a community drive was established to aid the family. The home has since been rebuilt. (Courtesy of James Quinn.)

On November 14, 1988, Milton firefighters responded to a reported fire in the area of Brush Hill Road near Metropolitan Avenue. Callers reported that they could see the blazing fire from their homes in the Roslindale section of Boston, several miles away. The fire was discovered to be at 636 Brush Hill Road, the former estate of movie chain magnate E. M. Loew, who no longer lived in the mansion. Upon arrival, firefighters found the three-story mansion fully involved in flames. In the photograph above, Milton firefighter William McLaughlin has positioned Milton ladder No. 1 and is preparing it for ladder pipe operations. The fire, which burned until the next morning and completely destroyed the uninhabited mansion, was determined to be caused by vandals. The site is now occupied by the stately homes of Loew Circle and Elias Lane. (Courtesy of James Quinn.)

On Friday evening, November 5, 1999, fire completely destroyed the cold storage warehouse owned by the HP Hood Company located at 88 Wharf Street in Milton Village. The 50,000-square-foot structure housed food for Stop and Shop and other area food chains. In the photograph above, Milton engine No. 4 arrives on scene with a newly established water supply hose line from a nearby fire hydrant. Boston ladder No. 6 is setting up its aerial for ladder pipe operations. The large stream on the left is from the ladder pipe of Milton ladder No. 1, placed in operation shortly after arrival.

This photograph of Milton ladder No. 1 operating at the Hood plant fire made the front cover of *Firehouse Magazine*'s January 2000 issue. The cold storage warehouse was stocking up for the coming Thanksgiving holiday. The *Boston Globe* reported that in all 10,000 frozen turkeys and more than a million gallons of ice cream were destroyed in the fire. Milton firefighters remained on scene for more than a week checking hot spots and flare-ups.

The seven-alarm fire burned for several days and required the response of many fire companies under the direction of Metro Fire District 13, including Boston, Weymouth, Brookline, Dedham, Needham, Braintree, and Quincy. The state hazardous materials team was on scene to monitor a huge tank of anhydrous ammonia used for the freezers in the warehouse. A Boston fireboat responded up the Neponset River to the rear of the building and operated in areas hard to reach by the land units.

The site of the spectacular blaze of November 5, 1999, is now occupied by the luxurious condominium complex known as Milton Landing.

# Six

# THE MILTON FIREFIGHTER'S RELIEF ASSOCIATION

The medallion of the Milton Firefighter's Relief Association was created for the purpose of decorating the graves of Milton firefighters, wherever they are interred. The association was first organized in 1892. Originally named the Milton Firemen's Relief Association, the term *firefighter* has come into more common usage and the official name of the association was changed in 1998. Since its founding, the main purpose of the association is to establish a fund for the assistance of members who became sick or disabled in the discharge of their duties.

Fire Chief George Choate (left) is seated next to Assistant Chief Ellerton Whitney in this photograph taken about 1895. These two men were the cofounders of the Milton Firemen's Relief Association in 1892. Choate was elected the first president of the association, and Whitney was chosen as its first treasurer and clerk. In this period, insurance companies were hesitant to cover firemen because of the hazards often associated with their line of work. The main purpose of the association was to help defray the medical bills of the firemen when they were injured in the performance of their duties. Later a fund was established to pay a death benefit to the surviving family upon the death of a member.

One of the first acts of the association was to hold a firemen's ball for the benefit of the men and the community. The program guide displayed here is from the sixth annual ball of the Milton Firemen's Relief Association held on January 15, 1897, at Milton Town Hall. Numerous booklets such as this are now carefully maintained in the Milton Firefighters Memorial Archives.

# TWENTY-FIFTH ANNUAL BALL

FOR THE BENEFIT OF

# MILTON
# FIREMEN'S RELIEF ASS'N

## TOWN HALL, MILTON
### Wednesday Evening, January 31, 1917

Music, STRACHAN'S Orchestra, 8 Pieces  TICKET, Admitting Gentleman and Ladies, $1.00
Concert, from 8 to 9    Grand March at 9
Dancing, from 9 to 3    Cars to All Points after the Ball

Milton Job Print, Local Office

This announcement poster of the 25th annual firemen's ball is a token of the success of the organization, then in its 25th year. The annual ball had become a popular event attended by many citizens of Milton each year. Note that dancing was from 9:00 p.m. to 3:00 a.m. and the last car left at 3:00 a.m.

This sketch was created by Milton firemen William J. Hicks and suggests a fun time was had by all at the 25th annual ball. The dance floor was located in the old town hall with the official town seal hanging above the stage. The dancers are enjoying the music of Strachan's Orchestra and Banjo Team, a popular local band that often played the firemen's ball in Milton. Directing the dancers are floor directors Henry Briarly (left) and Ashton McLeod (right). For added security, officer William Fallon and Chief Maurice Pierce of the Milton Police Department were present and are seen above right.

This image drawn by William J. Hicks in January 1923 shows how the firemen went door to door selling tickets to the firemen's ball each year. This practice was discontinued in the 1970s when a bulk mailing program was established for the purpose of selling tickets. This image includes Roger Sangster (left) and James Whelan (center) and his brother Frederick Whelan, the future fire chief. This ticket from the annual ball of 1930 shows that the price was still a bargain at $1 and Strachan's Orchestra, 10 pieces, was still the popular entertainer.

| Concert from 8 to 9 | Grand March at 9 | Dancing from 9 to 2 |

## THIRTY-EIGHTH ANNUAL BALL

### FOR THE BENEFIT OF

# Milton Firemen's Relief Association

## And Memorial Fund

### TOWN HALL, MILTON
### Wednesday Evening, April 30, 1930
### Ticket, $1.00

Strachan's Orchestra, 10 pieces                                    Holman, Caterer

Make Checks payable to Milton Firemen's Relief Association

Milton firefighters have been observing Firemen's Memorial Sunday each year since 1920 to honor their deceased members. On Sunday, June 28, 1928, a special ceremony was held at the Milton Cemetery where a monument, created from a boulder removed from the Blue Hills, was dedicated in memory of all who have ever served the Milton Fire Department. The small fire department had lost four members in the line of duty in the short space of 10 years, no doubt a leading factor contributing to this special tribute. The program, beginning with a parade to the Milton Cemetery from the Central Fire House, was highlighted by addresses from Josiah Babcock, chairman of the board of selectmen, and David Walsh, United States senator from Massachusetts. The parade became an annual tradition until it was discontinued in the 1970s, although Firemen's Memorial Sunday exercises are still observed each year at the memorial boulder in the Milton Cemetery on the second Sunday in June.

**Memorial Exercises**

and dedication of

**Memorial Boulder and Tablet**

by the

**Milton Firemen's Relief Association**

Milton Cemetery - - Milton, Mass.

SUNDAY, JUNE 10, 1928

3:00 o'clock

Milton firefighters march to the Milton Cemetery in the annual Firemen's Memorial Sunday exercises held on June 8, 1958.

107

All eyes are on the camera in this photograph taken in the Milton Town Hall auditorium, the location of the annual ball in 1951. The front row includes, from left to right, Lt. William Gustafson, call firefighter Henry Mersch, and firefighter James Whelan. (Mersch later became

Deputy Fire Chief Timothy Foley dances with his wife, Louise, at the annual ball held at Florian Hall in Dorchester in December 1975. To their right, Milton firefighter Robert McGee dances with his mother.

Milton Firemen's Relief Assoc.
Annual Ball, Dec. 5, 1951,
Milton Town Hall, Milton.

a Milton policeman.) For many years, the fireman's ball was held in the town hall. The food for the affair was prepared in the kitchen of the Central Fire Station across the street.

Beginning in 1920 and every year since, Milton firefighters have observed annual Firemen's Memorial Sunday services at the Milton Cemetery. In this 1975 photograph, firefighters, along with a local minister, their families, and friends, gather at the firemen's memorial monument located in the center of the Milton Cemetery to pay tribute to their deceased members. In formation are firefighter Joseph Angeloni, Deputy Chief John Hanafin, Lt. George Geden, firefighter Gil Hoadley, firefighter John Driscoll, Lt. Donald Affanato, firefighter Elliot Bent, and Rev. Francis H. Delaney of St. Mary of the Hills Parish.

Firefighter Edward Jerdon with Goliath, the fire department's mascot, pays tribute at the annual Firemen's Memorial Sunday exercises held in June 1975.

Milton firefighter John Driscoll lays a wreath of flowers displayed each year in honor of the department's past members. The plaque on the monument, which was designed by firemen William J. Hicks and Ernest C. Soulis, was first dedicated in a ceremony held in June 1928. The inscription on the monument reads, "Dedicated to the Glory of God / and to all who have / at Any Time Served the Milton Fire Department / At the call of duty they did not falter, and in the hour of / death they knew no fear / Milton Firemen's Relief Association / June 1928."

# Seven
# IN MEMORIAM

In a common effort in 1998, Milton firefighters and police officers joined forces to create a truly remarkable and lasting tribute to the memory of their fallen comrades—their brothers who gave their lives in the performance of their duties to the citizens of Milton. Assisted by a throng of citizens in attendance, the Milton Fire and Police Departments dedicated the Milton Police and Fire Memorial Monument in the newly created M. Joseph Manning Park in East Milton Square. The sacrifices made by these six members of the fire department are recalled in the following pages.

**Milton Police & Fire Memorial**

**DEDICATION**

**OCTOBER 25, 1998     1:00pm.**

**M. JOSEPH MANNING CITIZENS PARK
EAST MILTON SQUARE**

**DEDICATION COMMITTEE**
*WALTER M. "SKIP" CONWAY, MPD    BRIAN DOHERTY, MFD
JOSEPH VOGEL, MFD RETIRED    LT. RICHARD WELLS, MPD
ALFRED D. THOMAS    M. JOSEPH MANNING    DANIEL TARPY*

In one of the most tragic days in the history of the Milton Fire Department, Thomas McDermott (left) and Patrick Moran were killed instantly when the ladder truck they were riding in was struck by a streetcar at the intersection of Reedsdale Road and Canton Avenue on May 16, 1918. They were returning from an alarm of fire at box No. 64, a small fire at a home on Centre Street. The accident, which injured four other firemen, resulted in the first line of duty deaths ever recorded in the history of the Milton Fire Department. McDermott was a veteran Milton firefighter who began his career with the department in the 1890s. Moran, an immigrant from Ireland, was a call fireman who had responded to the fire from his job with the water department. This photograph of the tragic scene was taken within hours of the accident in front of the Milton Public Library on Canton Avenue, as onlookers gathered to witness the devastation. In the aftermath of the tragedy, townspeople established a memorial fund to assist the families of the deceased firemen.

On March 28, 1920, at the scene of a brushfire on Washington Street in East Milton, Milton fireman Henry Trull collapsed while working to extinguish the blaze. He never recovered, becoming the third Milton fireman to die in the line of duty. Trull was remembered as a man of the finest character who was looked up to by the men, conscientious in everything he undertook. He was the engineer of the steam engine before taking over as the driver of the new motor engine, engine No. 1, when it was first delivered in 1915.

On October 21, 1921, Edward Frost, driver of engine No. 1, was killed after the engine he was driving crashed into a telegraph pole on Adams Street in East Milton. Frost had been responding from the Central Fire Station to an alarm of fire on Grafton Avenue. A 26-year veteran of the department, Frost was remembered as a highly respected citizen with an excellent fire department record. Incredibly, the Milton Fire Department had experienced its fourth line of duty death in less than four years. This portrait of Frost was done by William J. Hicks about 1916.

# FIREMAN IS KILLED

## GEO. B. HERSEY DIES IN FALL FROM LADDER

### Was Fighting Two Alarm Blaze In Frigid Weather At the Shoolman House — Loss To Building and Contents Estimated At $15,000

George B. Hersey, a Milton fireman for nearly 34 years, was killed Wednesday morning when he fell from a ladder at the old Vose house, occupied by Samuel Shoolman and family at 170 Pleasant st., East Milton, where the department was fighting the worst blaze this town has seen in nearly two years.

No one can say with certainty why Hersey lost his grip upon the ladder, to fall two stories to his death. He had mounted the ladder but a moment before, carrying a hose. Imme-

In the early morning hours of February 14, 1934, fire lieutenant George Hersey lost his footing on an icy ladder and fell back, striking his head on the ground. He was taken immediately to Milton Hospital where he was pronounced dead on arrival. Hersey, the fifth member of the department to die in the line of duty, was memorialized by the Metropolitan Sparks Club shortly after his death. The plaque that was placed on a wall at the Central Fire Station reads, "In memory of Lieutenant George B. Hersey, Engine 1, Killed in Action, February 14, 1934."

In the annual ball booklet of 1966, the Milton Firemen's Relief Association remembered several members who had passed away that year, including firefighter Jeremiah Noris (center), who died as a result of his injuries suffered at a basement fire on June 6, 1966, at a residence on Wyndmere Road in Milton. Also honored were firemen Stephen Monahan and Harold Carlson, active firemen who died while off duty that year, well before their time. Below is an undated image of Jeremiah Noris as a young man, done by Milton fireman and artist William J. Hicks.

115

In a solemn procession, Milton firefighters and police officers, together with Boston and Quincy firefighters, Boston police, and Massachusetts state police officers, marched in East Milton Square to dedicate the Milton Police and Fire Memorial Monument. The honor guard was led by police motorcycle squads and the Boston Police Gaelic Brigade. The ceremony was directed by retired Milton firefighter Joseph Vogel and included such local dignitaries as Milton selectman Richard Neely; Rev. Laurie Bilyea, pastor of First Parish Church; M. Joseph Manning, former state representative; Rev. Gilbert Phinn, pastor of St. Elizabeth's Church; and Rabbi Nathan Korff of Congregation B'nai Jacob. Milton patrolman Louis Bullard sang the national anthem. (Courtesy of Robert McGee.)

The monument was created with the assistance of funeral home director Alfred D. Thomas and Daniel Tarpey of Celtic Monuments. The names of two Milton police officers inscribed on the monument memorialized their sacrifices. Emory Farrington was shot and killed in an isolated section of town near Great Blue Hill on June 8, 1922, as he was investigating a stolen car. Edward Lee was shot to death on May 16, 1940, at the Milton police headquarters as he was removing a criminal from a police car. The name of Milton firefighter Jeremiah Noris was added at a later date. Each June, on Firemen's Memorial Sunday, Milton firefighters assemble at this monument to remember these past members who were killed in the line of duty. The inscription reads, "This Monument is Dedicated to the Memory / of those Public Safety Officers / Who gave their lives in service to the / Citizens of the Town of Milton." (Courtesy of Robert McGee.)

# ATHERTON STREET FIRE STATION

## CENTENNIAL

### 1901 - 2001
### SUNDAY APRIL 29, 2001

Milton firefighters, with a throng of supporters, gathered to commemorate the 100th anniversary of the Atherton Street fire station on April 29, 2001. The ceremony was held in front of the firehouse with firefighters, local citizens, and town officials on hand. (Courtesy of Robert McGee.)

The firehouse was decorated with flags and bunting and included, besides Old Glory in the center, the town of Milton flag on the left and Massachusetts state flag on the right. Edward Duffy, president of the Milton Historical Society, presented a historical talk for the occasion. During the ceremony, Milton firefighters and attendees recalled the memory of Mary Saltonstall who, at age three, was killed by fire at her family home on Brush Hill Road. Her untimely death in February 1901 stunned the town and was a moving force toward the establishment of the Atherton Street fire station. Later a monument erected in front of the firehouse was dedicated in her memory. (Courtesy of Robert McGee.)

# Eight
# MILTON FIRE AND RESCUE

In 1992, Milton firefighters gathered for this photograph in front of the Central Fire Station in Milton following a search and rescue class sponsored by instructors from the state fire academy. From left to right are (first row) James Daly, pet mascot Duke held by Brian A. Doherty, Paul Vincent (standing), Edward Jerdon, and Deputy Chief John Foley; (second row) unidentified instructors in white shirts, Robert Byron, Mitchell Sumner, Bradford Ellis, Paul McNulty, Angel Calderone, Joseph Garrity, Ronald English, Thomas Cicerone, Deputy Chief Jay Devine, Eliot Lyons, unidentified, William Forde, Kevin Finerty, and Lt. John Fasano. With fire suppression the primary mission, the modern Milton firefighter is a multiskilled professional trained to handle a variety of emergency work, including emergency medical services, hazardous materials incident mitigation, and water and ice rescue.

Lt. Andrew Staunton (left) and firefighter Edward Jerdon review their CPR skills in the training room at the Central Fire Station. Milton firefighters receive biannual training in a variety of emergency medical services, including cardiac defibrillation.

Milton firefighters Robert McGee (center) and Kevin Finerty (right) demonstrate the Jaws of Life for a crowd gathered at a Milton Hospital health fair event held in 1996. Lt. Robert Byron observes at the left.

A state hazardous materials technician advises Deputy Chief John Foley on the proper handling of an unidentifiable substance found at the town animal shelter in the winter of 1998. A caller had reported noxious fumes coming from the office area of the building. (Courtesy of Robert McGee.)

A Milton firefighter removes the unknown substance from the facility, under the direct supervision of the hazardous materials technician. A ventilation fan has been placed in the doorway and is located above another firefighter who is preparing to exit the building. The substance was later identified and determined potentially harmful. It was properly disposed of later. Currently three Milton firefighters serve on the state hazardous materials response team. (Courtesy of Robert McGee.)

A state police officer directs traffic as Milton engine No. 2 races to the scene of a reported school bus accident on the northbound lane of the Southeast Expressway in East Milton. With their firehouse located along the expressway in East Milton Square, Milton firefighters are often called to the scene of serious vehicle accidents, fires, and emergency medical incidents on the busy highway leading in and out of the city of Boston. This photograph, taken in 1998, shows the difficulty the apparatus often experiences trying to arrive safely on the scene of these incidents.

One victim was removed from the school bus, another from the car, and both were rushed to a Boston hospital with severe injuries. Firefighters stood by for an hour during cleanup. The photograph demonstrates the challenges the modern fire department encounters and must be trained to properly mitigate every day if necessary.

An ominous cloud of black, sooty smoke arises over East Milton Square in this photograph taken in 2005. Firefighters were called to the scene from the East Milton fire station (in the lower left of this photograph) and found a car fully involved in flames on the northbound lane of the Southeast Expressway just under the newly created overpass tunnel. The thick, sooty smoke blinded drivers, causing numerous accidents within the tunnel. The 600-foot tunnel was created in 1997 when the depressed highway was decked over with a park in an effort to restore vitality to East Milton Square.

Responding firefighters were hampered by a blinding smoke condition that made it difficult to locate the source. The car fire, located at the opposite end of the 600-foot tunnel from where they entered, was quickly extinguished and ventilation procedures were initiated with no injuries.

A Milton firefighter approaches a "victim" in the water during a training session in 1998. Since acquiring the newly developed ice rescue sled in 1995, ice rescue drill is held each winter on Turner's Pond in Milton.

A rescuer has attached a safety harness to the victim before signaling to firefighters to pull them ashore. The cold water survival suits the firefighters are wearing are U.S. Coast Guard approved and the same as carried aboard fishing vessels at sea.

Milton firefighters receive directions from an instructor of the Massachusetts State Firefighting Academy in Barnstable on Cape Cod in this photograph taken in 2002. In the "burn building," firefighters receive instructions on interior firefighting, search and rescue, and ventilation techniques from state fire academy personnel.

Firefighters get into position to attack a simulated basement fire in this photograph taken during training in 2002. The training fires offered at the academy help firefighters tune up their skills for the next "big one."

Milton fighters received training in combating flammable liquid fires at Logan International Airport in East Boston in 2005. The initial stage of the exercise involves fighting the fire using wide pattern water fog streams only, a difficult yet successful approach. In the next stage, firefighters attack the blaze with foam streams and are much more successful. With miles of highway systems meandering through Milton, the potential for a large-scale flammable liquid fire in Milton is as great as any other suburban town in America.

Countless aircraft approach Logan International Airport within airspace above Milton each day. Milton firefighters prepare for the possibilities of encountering these fires through training exercises such as this.

In 1996, Milton firefighters, led by Fire Chief Donald Affanato (center in front of flagpole), gather together at the firemen's memorial boulder in the Milton Cemetery for the traditional Firemen's Memorial Sunday exercises held each June since 1920. With the chief are, from left to right, firefighter Brian A. Doherty, firefighter Thomas Cicerone, firefighter Michael Hanafin, Deputy Chief Malcolm Larson, unidentified, Deputy Chief Brian Linehan, Deputy Chief John Foley, firefighter Robert McGee, firefighter John Regan, Chief Donald Affanato, firefighter Bradford Ellis, Lt. Andrew Staunton, firefighter Paul Kelly, Lt. Mitchell Sumner, firefighter James Daly, retired fire chief John Hanafin, firefighter Kevin Finerty, and firefighter Joseph Angeloni.

The firemen's memorial boulder is adorned with firefighter turnout gear and an ax as the newly acquired Milton engine No. 4 stands by at the annual memorial services held in 2000.

127

## ACROSS AMERICA, PEOPLE ARE DISCOVERING SOMETHING WONDERFUL. THEIR HERITAGE.

Arcadia Publishing is the leading local history publisher in the United States. With more than 3,000 titles in print and hundreds of new titles released every year, Arcadia has extensive specialized experience chronicling the history of communities and celebrating America's hidden stories, bringing to life the people, places, and events from the past. To discover the history of other communities across the nation, please visit:

## www.arcadiapublishing.com

Customized search tools allow you to find regional history books about the town where you grew up, the cities where your friends and family live, the town where your parents met, or even that retirement spot you've been dreaming about.